IMAGES
of America

MINEOLA

D1157825

On the Cover: In September 1956, Mineola celebrated its Golden Jubilee in style. Events were scheduled beginning on September 15, culminating in a huge Jubilee Parade on Saturday, September 22. The VFW entry is pictured here headed south down Mineola Boulevard. Leading the parade was Irene Sinchaski, world champion baton twirler. The Eastern Seaboard Baton Twirling Championships, which Sinchaski won two years in a row, originated in Mineola with Harry Tangemann. (Courtesy of the Mineola Historical Society.)

IMAGES
of America

MINEOLA

From the Heart of Mineola !

Margaret-Ann Farmer and Cathy Sagevick
Foreword by the Mineola Historical Society

Margaret Ann Farmer *Cathy Sagevick*

2017

ARCADIA
PUBLISHING

Copyright © 2017 by Margaret-Ann Farmer and Cathy Sagevick
ISBN 978-1-4671-2744-8

Published by Arcadia Publishing
Charleston, South Carolina

Printed in the United States of America

Library of Congress Control Number: 2017940059

For all general information, please contact Arcadia Publishing:
Telephone 843-853-2070
Fax 843-853-0044
E-mail sales@arcadiapublishing.com
For customer service and orders:
Toll-Free 1-888-313-2665

Visit us on the Internet at www.arcadiapublishing.com

To the late Neil Young,
president of the Mineola Historical Society:
historian, mentor, and friend.

CONTENTS

FOREWORD

Long Island is full of fascinating and important history, on both the local and national scale. The village of Mineola has played an essential role in many of the key aspects of this history. Currently the county seat, and in many respects the very core of Nassau County, it also has a rich and storied past.

The name *Mineola* is derived from the Algonquin word meaning "pleasant place." While the incorporated village of Mineola has been a pleasant place to live, work, learn, and play for more than 100 years, the history of Mineola extends beyond that time, and its significance extends beyond simply being pleasant.

It is our great pleasure to have readers catch a glimpse through the windows of Mineola's history via the pages of this book. The authors, two local librarians and residents, have scoured the more than 4,000 photographs, historical documents, and objects at the Mineola Historical Society to tell the story of our town. Within these pages, images of the people and streets of Mineola's past serve as fascinating reminders of the many ways in which Mineola has made its mark on our island's and our nation's history.

Michael Marinak, Treasurer
Mineola Historical Society

ACKNOWLEDGMENTS

We had the pleasure of meeting and consulting with many people who helped us along this incredible journey. Our thanks and appreciation go out to the following in no particular order: president Tom Murtha and treasurer Mike Marinak, both of the Mineola Historical Society, for greeting us each week with smiles, stories, and a wealth of information; the members of the Mineola Historical Society, past and present, for faithfully preserving Mineola's memories and allowing us access to tell this story; the late Thomas Barrick, Mineola resident, for his copious notes and research on the history of Mineola; photographers Joe Burt, James Drennan, and Henry Otto Korten for capturing these images, thereby making time stand still; Michael Brosnan for his help in obtaining images from the Cradle of Aviation Museum; Al Velocci; Howard Kroplick; Iris Levin; Stephanie Gress; Brian Strauss; Russ Sutherland; Jim Rementer; the L'Ecuyer family for contributing the most unusual item during our research; Jillian Carney; Jenny Lynch, historian and corporate information services manager of the US Postal Service; Lisa Rae Castrigno for her exceptional organizational skills; and our families and friends, whose patience and encouragement in equal measures saw us through this labor of love. Unless otherwise noted, all images appear courtesy of the Mineola Historical Society.

INTRODUCTION

The history of Mineola began long before its official incorporation in 1906, and it was advancements in transportation that would truly define the growth and development of the village. Two hundred years ago, the flat, fertile lands of the Hempstead Plains held only a small cluster of farms. In 1836, the Long Island Rail Road (LIRR) began construction of a line leading eastward from Jamaica running through the sparsely populated lands to Hicksville. There were only two stops along the line prior to 1839: the first was in Brushville, today's Queens Village, and the other in Clowesville, just west of Mineola's current station. Passengers getting off there would walk slightly over a mile north to reach the county courthouse located on Jericho Turnpike near Herricks Road. In 1839, rails were laid east of the Clowesville stop that connected the village of Hempstead with the main line. A single train ran out to Hempstead in the morning, returning in the evening. A small settlement grew up around this new junction, known simply as Hempstead Branch, establishing the roots of Mineola.

The first official post office for Hempstead Branch was established on October 29, 1844. John S. Wood served as the first postmaster, collecting mail for approximately 10 families. As individual mail delivery did not exist at the time, residents would stop by to pick up their mail. By 1858, Luke Fleet Jr. was the postmaster, distributing mail from his Main Street general store. On June 12 of that year, the post office name was officially changed from Hempstead Branch to Mineola. There are several stories of the origin of the name Mineola, ranging from the fanciful to the unlikely. Among others, these include tales of princesses, an Indian chief, and a preference for the musical-sounding Indian word. What is known is that prominent resident Samuel Searing, for reasons lost to history, proposed the name, and the motion was carried.

Although the true source of the name is unknown, its meaning at least is officially understood. The Smithsonian Institution Bureau of American Ethnology determined in 1916 that the name is of Delaware Indian origin and comes from a longer form, Meniologamike, meaning "a pleasant or palisaded village." Current research turned up no fewer than three more alternate spellings of the word. According to Jim Rementer, director of the Lenape Language Project, the word translates as "a rich spot of land that is pleasing or pleasant, especially if it is surrounded by barren lands." This surely fits the early description of the land in this area before development.

A major boon to the growth of Mineola was the decision in 1866 of the Queens County Agricultural Society to locate its annual fair here. The Town of Hempstead offered to lease 50 acres of plains situated between Hempstead and Mineola for a nominal annual fee. In the end, 40 acres were provided bounded by Old Country Road, Washington Avenue, Eleventh Street, and the Hempstead branch of the railroad. This preeminent event drew large crowds of visitors and numerous exhibitors and became known as the Mineola Fair. People from the western cities of Flushing, Jamaica, and Manhattan would ride the train out to the fair. The railroad offered reduced rates for fairgoers, while free freighting of animals and exhibits to and from the fair was an added incentive to exhibitors. Extensive and detailed newspaper accounts were printed daily in New York papers, solidly establishing Mineola as an event destination. The fair was such a

well-known event that horses from as far away as California came to be entered into the races. Today, the county courthouse complex can be found on the original fairgrounds. The fair, in its agricultural format, has found a new home at Old Bethpage Village Restoration, while the village of Mineola now hosts an annual street fair.

The connection of towns north and south of Mineola's main rail line was accomplished via trolley. Several different traction companies laid lines in the early 1900s, crisscrossing the village with tracks. In the downtown area on Main Street, one could catch a trolley heading to Valley Stream, Port Washington, or Hicksville. Trolleys were a popular mode of transportation that eventually succumbed to the automobile.

Mineola continued its successful expansion into the 20th century as the automobile became the vehicle of the modern age. William K. Vanderbilt Jr. brought his passion for automobiles and racing to Mineola's roads in 1904. The Vanderbilt Cup Races attracted car owners, drivers, and spectators to Long Island. Mineola featured prominently in the races, as cars sped along Jericho Turnpike past Krug's Hotel on Willis Avenue, and in 1905, to the start/finish line and grandstand near Mineola Boulevard. A tragic death of a spectator during the 1906 race sparked the subsequent development of Vanderbilt's Motor Parkway, a dedicated paved road for automobiles. Here, too, Mineola was a favored place for autos, having its own entrance and toll lodge to the roadway off Jericho Turnpike. The advent of the automobile gave rise to new businesses in auto dealerships, garages, and gas stations in the village.

Mineola also established itself both nationally and internationally when it was chosen by early flyers as an ideal spot for the burgeoning field of aviation. Glenn Curtiss often stayed in Pete McLaughlin's Gold Bug Hotel on Main Street, prompting that enterprising gentleman to proclaim it "Aeronautical Headquarters." Flight schools, distance races, and test flights were all conducted on the Hempstead Plains Aviation Field, commonly known as Mineola Air Field. The first official US Postal Service airmail delivery was made on September 23, 1911, by Earl Ovington flying from Garden City to Mineola. Today, the original flying fields of Mineola, where pioneers of aviation got their wings, lie outside the geographic boundaries of the village, but our history is forever linked with their achievements.

When it was selected in 1898 as the seat of Nassau County over Hicksville and Hempstead, Mineola's establishment as an important crossroads was cemented. Its central location has always made it perfectly suited for the growth it has seen over the past 178 years. As a hub for transportation, law and justice, suburban living, pioneering industries, and entertainment, Mineola's contributions have prompted village officials to designate it "The Heart of Nassau County." Mineola has lent its melodious name to a shoe, a carriage, August Belmont's yacht and private railcar, several towns across America, a line of greyhound racing dogs, a song, a girl's name, and a fruit.

In some ways, the past has never left Mineola, even though many of our beautiful old buildings no longer exist. Civic organizations and clubs that had their beginnings in our earliest days still continue to be active. Mineola has historically thrived on the ideas and actions of citizens with a strong commitment to community involvement. The village of Mineola has had a full and notable past, a mere fraction of which we are able to present in this book. Through these images, we hope to provide a view of Mineola "the way it was" and inspire future generations to appreciate their own place in Mineola's history.

One

HUMBLE FARM BEGINNINGS

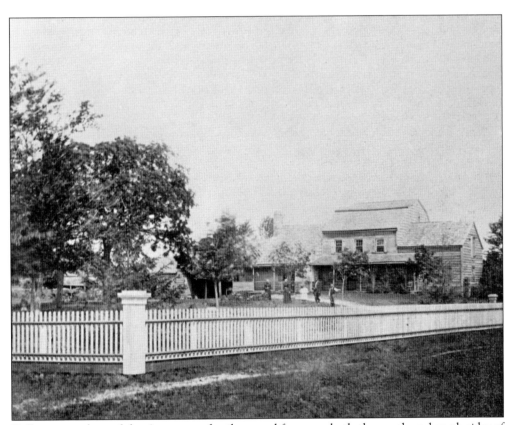

Different members of the Armstrong family owned farms on both the north and south sides of Jericho Turnpike near Herricks Road. The house pictured here belonged to Joseph Armstrong and was built in the 19th century. It was on the northwest corner of Jericho Turnpike and Herricks Road next to the old Queens County Courthouse. The house burned down in 1932.

This distinguished gentleman is Bergen Mott Simonson, photographed approximately two years before his death in 1897. Simonson purchased acreage in 1893 in Mineola for around $16,000, which included a large clapboard house, barns, and outbuildings. He and his wife, Phebe Elizabeth Whitson, had 13 children, the last of whom was born just a week after Simonson's death.

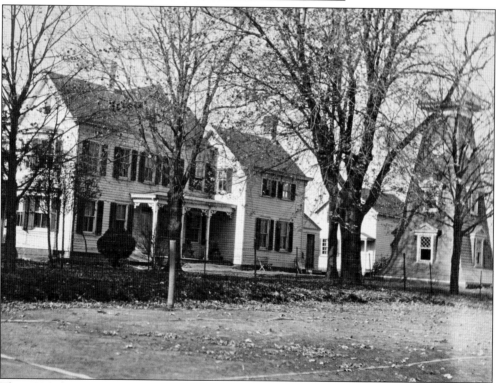

This 1896 photograph shows the Simonson farmhouse on the north side of Jericho Turnpike. It would have been approximately opposite today's Chaminade High School field and roughly between Emory and Saville Roads. Those roads were not yet in existence at the time of this photograph. Simonson owned a total of 70 acres on both the north and south sides of Jericho Turnpike.

Potatoes were a popular crop in the area, as can be seen here on the Burkard farm. Chris Burkard farmed the land between Mineola Boulevard and Willis Avenue running from Hillside Avenue south all the way down to Jericho Turnpike. Today, this area is divided by side streets, and Burkhard Avenue can be found one block west of Mineola Boulevard.

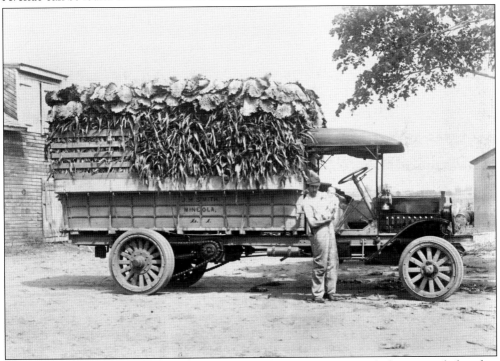

During the 19th century, the level and fertile soil of the Hempstead Plains coupled with a convenient railroad junction made Mineola an ideal center for farming. By the turn of the 20th century, Mineola was home to 24 major farms raising a wide variety of produce and livestock. This 1915 photograph shows local farmer Jack H. Smith with his market truck.

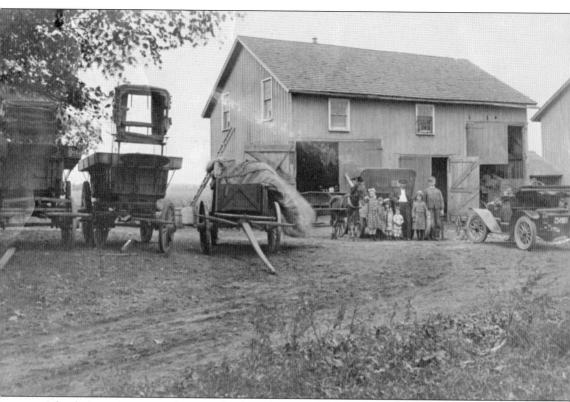

After being tenants on a farm north of Jericho Turnpike near Marcellus Road, the Frank family purchased 40 acres of property on Emory Road in 1911 from Bergen Mott Simonson. It was on the south side of Jericho Turnpike where Mineola Middle School currently stands. The Frank family lived in Mineola until 1980.

Five of the Franks' seven surviving children are in this photograph taken on their farm. The eighth child, a twin, died before the age of three. Paul Frank was an immigrant from Germany who arrived in America as a child of about five years in either 1885 or 1886.

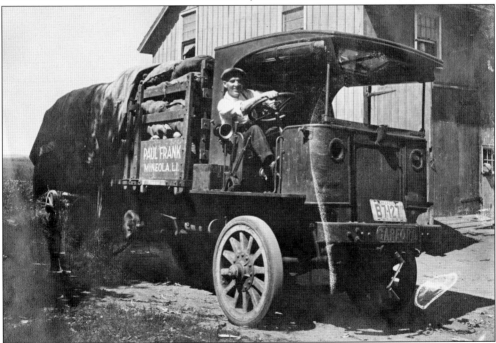

Paul Frank is pictured here around 1916 proudly displaying a truckload of potatoes, which was their main crop. The vehicle is quite possibly the one mentioned in a September 3, 1914, item in the *Hempstead Sentinel*, which announced, "Paul Frank has purchased a new motor truck for use in carrying produce to city markets." The truck was manufactured by the Garford company of Elyria, Ohio, and had a five-ton capacity.

Situated on the northeast corner of Old Country Road and Roslyn Road was the Albertson Estate, pictured here. The property stretched north along Roslyn Road bordered by the Long Island Rail Road. It is from this family that Albertson Road, running one block north and parallel to Old Country Road, takes its name. Thomas Willetts Albertson was born in 1813 in Westbury, married Harriet Townsend in 1845, and lived on this homestead until his death in 1874. The farm had one of the only wind-powered mills in the county, and Albertson was reputed to be of such a generous nature that he would refuse money for his milling services, instead taking his payment in grain.

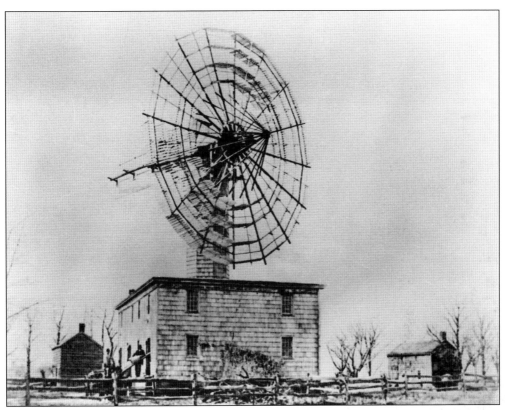

Located on the Albertson estate was this impressive gristmill built by Thomas Albertson in 1847. The mill was hand hewn, and local farmers brought their wheat here to be ground into flour. When the wheel was damaged beyond repair by a storm, it was removed and the building left as shown here. The estate had a storied history. During the Civil War, it operated as a private school called the Grain Cistern Academy. World War II saw the property being utilized by the Airborne Instrument Laboratory. In 1950, the 14-room house became headquarters for Nassau County's Civil Defense unit. All the buildings on the property were eventually torn down to make way for the Birchwood Apartments that can be seen today.

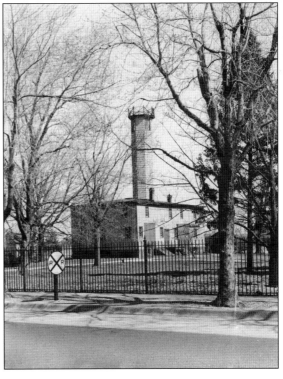

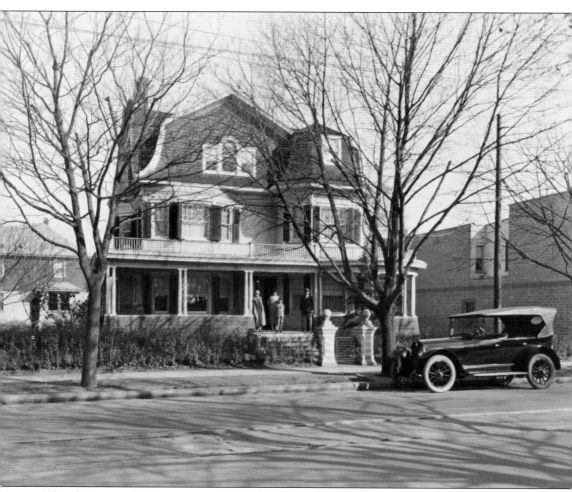

This distinctive home once stood on Mineola Boulevard between Cleveland and Harrison Avenues. It was the residence of Judge John Buhler, the first president (mayor) of Mineola after its incorporation as a village in 1906. The Gilligan family, who later purchased the home, are pictured here on the front porch. The automobile parked by the curb is from the 1920s. (Courtesy of Queens Library, Archives, Joseph Burt Photographs.)

In the 1890s, this was the home of county coroner Dr. Erasmus D. Skinner and his family. On a summer evening in 1898, it was also the scene of a mysterious attempt on the doctor's life. Answering a midnight summons for his services, he was shot through the window by an unseen attacker. The doctor recovered, but the attacker was never identified. Sitting on the steps are, from the top down, Dr. Skinner's wife Annie Skinner, his granddaughter Anna Skinner Poole, and his daughter Belle. Standing to the right is Fred, Dr. Skinner's helper from the nearby Children's Home.

The Burt family homestead was built in the 1700s along Old Country Road. The family farmed land that today is part of Roosevelt Field. One notable member of the family was Joseph Burt Sr., a well-respected commercial and hobby photographer of Long Island life during the early 1900s. His photographs run the gamut from farms and residences to businesses, politicians, and events all over the island, including this photograph.

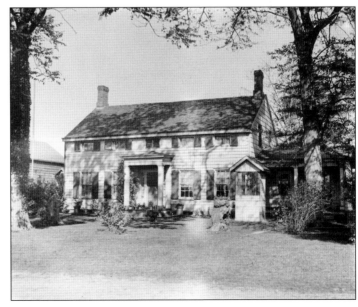

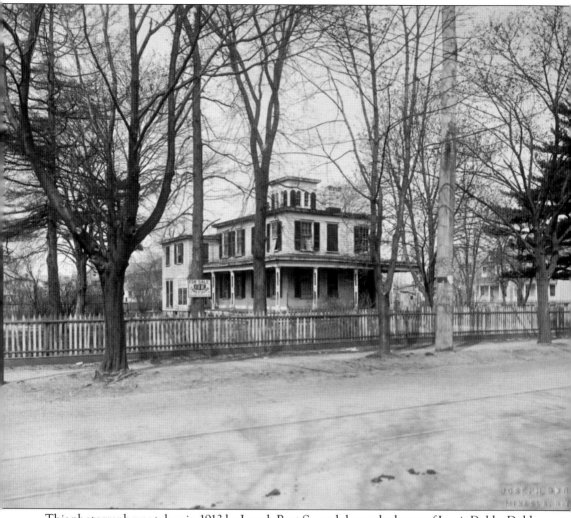

This photograph was taken in 1913 by Joseph Burt Sr. and shows the home of Lewis Dolde. Dolde lived in Mineola for 45 years, and for 16 years worked for the village water department, eventually rising to the position of assistant superintendent. Lot sizes were quite large in the 19th century, and this property on the west side of Willis Avenue extended the length of the block between Grant and Garfield Avenues. In 1898, J. Palmer leased the barn on the property and installed a bakery oven. He intended to capitalize on the booming industries in the area by selling baked goods to road laborers and construction crews. The home was torn down in 1915.

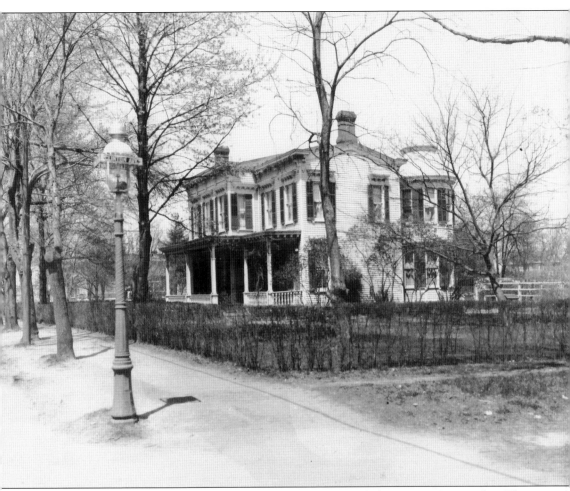

The gas lamps atop the decorative light posts in this photograph date it to 1914 or earlier. The home, owned by insurance broker Charles Free, was built on the northeast corner of Willis and Clinton Avenues. This puts it opposite the Dolde estate, giving a good idea of how picturesque the avenue once looked. The Free family had a total of seven children: three sons and four daughters. Charles Free was 65 years old when he died in a freak accident in December 1918 after falling while crossing the tracks of the Mineola station. He bled to death while awaiting an ambulance to transport him to the nearby Nassau Hospital. (Courtesy of Queens Library, Archives, Joseph Burt Photographs.)

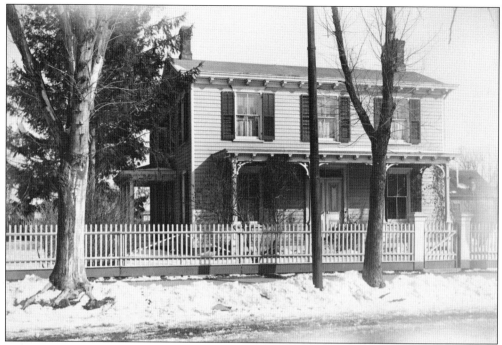

Many of the homes in the village were named for the family who first owned them and were referred to as such by subsequent owners. The Millington house originally belonged to Fred Millington, an English immigrant who was in the sash and blind business. It was on the eastern side of Main Street between First and Second Streets. The architectural style of the home dates it to around 1880–1890. (Courtesy of Queens Library, Archives, Joseph Burt Photographs.)

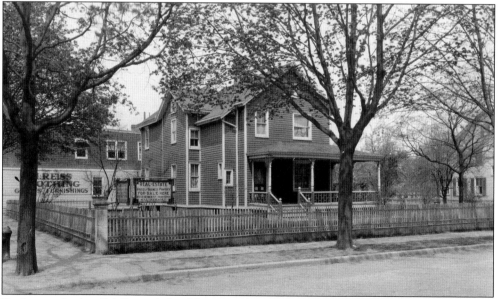

Real estate broker Sal Ramagli lived here on the northeast corner of Mineola Boulevard and Second Street. The sign on the front lawn indicates that his business office was located around the corner at 101 Main Street. Ramagli was elected treasurer of the Long Island Real Estate Board in 1927 and was also president of the Lions Club.

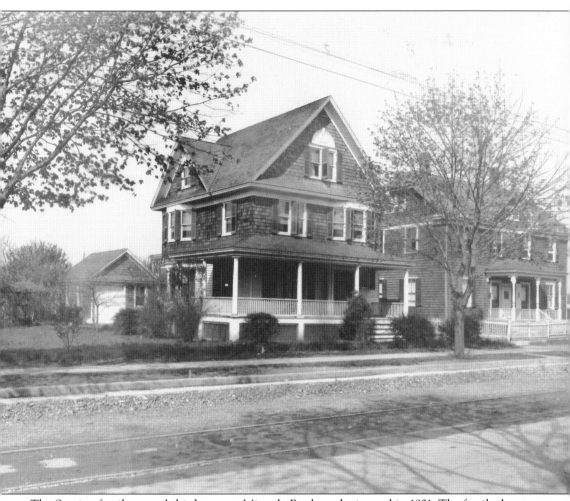

The Searing family owned this home on Mineola Boulevard, pictured in 1921. The family dates to the earliest beginnings of Mineola. At the time the first post office was opened on October 29, 1844, the Searings were among approximately eight families receiving mail. Many streets in the village are named after these early families. Searing Avenue today is off Willis Avenue a few blocks north of Old Country Road. (Courtesy of Queens Library, Archives, Joseph Burt Photographs.)

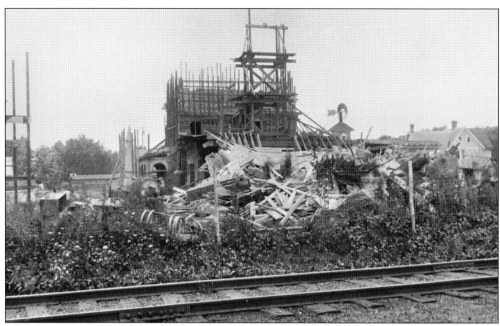

The grand house and garage planned for the Robert Graves family suffered a catastrophic setback during construction when the east tower of the garage structure collapsed on the morning of September 10, 1906. The accident resulted in the deaths of three workmen and injured dozens more. At the time, the cause was thought to have been a combination of a subpar cement mixture, not allowing time for it to set properly, and rushing to complete the work in time for the Vanderbilt Cup Race the following month. Ultimately, a grand jury found no single person guilty of any criminal liability. Within a year, the garage had been rebuilt and was hailed by the *Brooklyn Daily Eagle* as "the finest and most complete garage in the United States." The two towers were three stories each, complete unto themselves. The building featured glass skylights, electric lights and alarms with control switches in Graves's quarters, and a complete stable in addition to a carriage room.

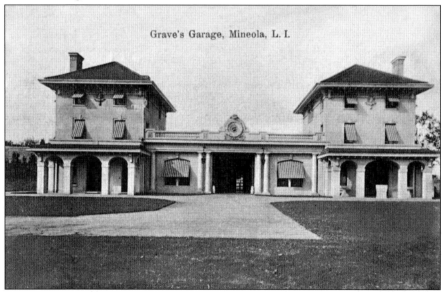

Grave's Garage, Mineola, L. I.

Two

A Fair to Remember

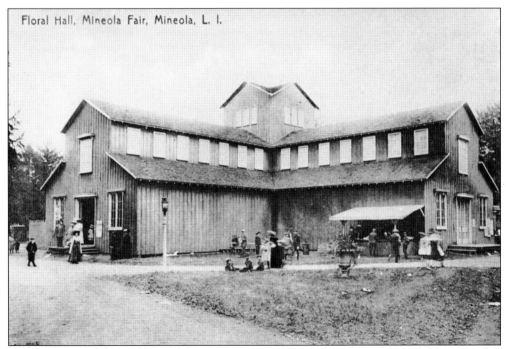

Floral Hall, Mineola Fair, Mineola, L. I.

The first Fair and Cattle Show of the Queens County Agricultural Society was held on October 13, 1842, in Hempstead. Thereafter, annual fairs were held on various members' farms. In 1866, the fair found a permanent home in Mineola. Floral Hall, the main exhibition building, is pictured here in the 1890s. This iconic building was one of the first to be erected at the new site.

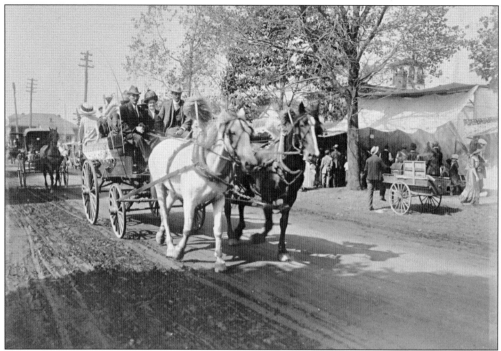

By 1867, the Mineola Fair was drawing crowds of up to 15,000 people a day. Most would arrive in horse-drawn carriages such as these. Parking was an issue then just as it is today. For the general public, 500 hitching posts were available. Wagon sheds were built for life members of the Agricultural Society who could afford the cost in addition to a $2 annual rental fee.

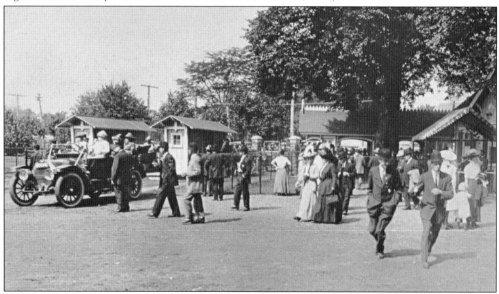

This photograph shows one of several entrances to the fair along Old Country Road. Initially, automobiles were not allowed on the fairgrounds. By 1902, however, a small area for parking had been designated. Vehicles needed to enter through the northwest gate and were required to move slowly so as not to frighten the horses. Entrance fees for nonmembers of the Agricultural Society began to be collected at the gates in 1849.

The superintendent's office was always busy on the opening day of the fair. Especially in the early days, animals and other entries were delivered the morning of the first day. In this photograph, Joe Andrews is on the left with Henry Skinner. Andrews was general superintendent of grounds for a number of years. Skinner was the son of Mineola doctor Erasmus D. Skinner.

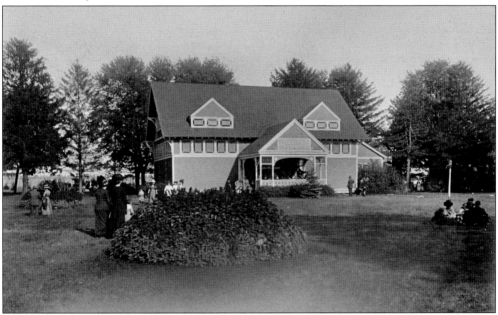

Fairgoers interested in all manner of domestic arts would visit the Ladies Building, which cost $2,800 to complete in 1889. An 1895 newspaper article described the building as handsome, being recently painted red and yellow. A later addition costing $1,700 provided more space. Needlework, embroidery, tatting, table articles, and more all competed for premiums (prizes). Oil paintings and amateur photography were also on exhibit.

SCHEDULE OF PREMIUMS

OFFERED FOR COMPETITION AT THE

21st Summer Exhibition

— OF THE —

QUEENS COUNTY

AGRICULTURAL SOCIETY,

TO BE HELD AT THE

FAIR GROUNDS, MINEOLA, L. I.

— ON —

Wednesday & Thursday, June 15 & 16, 1887.

FLUSHING, N. Y.
FLUSHING DAILY JOURNAL STEAM PRINTING ESTABLISHMENT,
1887.

Premium booklets detailed all the categories, rules, and prizes for entries in the fair. Departments ranged in scope from wild and domestic animals, household products, and flowers, fruits, and vegetables. Henry Woodnut and his daughter Hannah, Anna Searing, and Deborah Armstrong were some of the Mineola residents who submitted entries in 1887. Henry Woodnut won First Premium for his Jersey bull, as well as prizes for other animals.

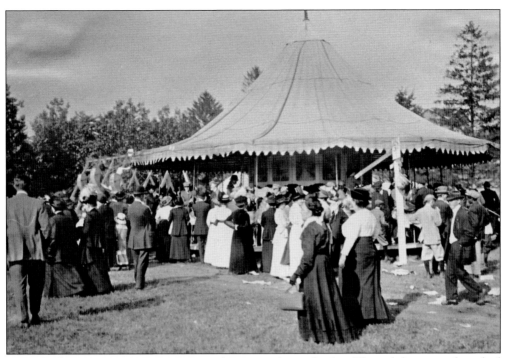

From the beginning, newspapers reported extensively on the fair. The exhibits were described in detail, names of premium winners were printed, and everything else from crowd size to the weather was published. Articles appearing in the *Brooklyn Daily Eagle* in the early 1900s even mention crowds at the merry-go-rounds, such as the one seen here.

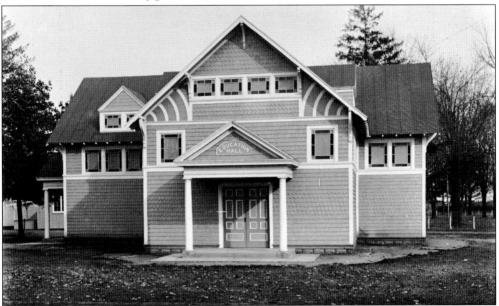

Education Hall was erected in 1914 and was open to displays by students in public schools of Nassau County. Exhibits were presented by schools as a whole, as well as individual students. An addition to the building was made in 1928 at a cost of $3,370. In 1933, exhibits of industrial arts were given space here.

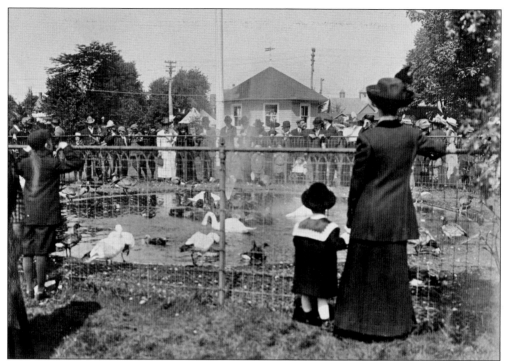

There were many interesting exhibits at the fair, such as this bird enclosure, around which a crowd has gathered around 1900. In the early years of the new century, the focus of the fair was not solely on farming and agriculture. Fairgoers could also see acts such as trick horse shows, trapeze artists, and baseball games.

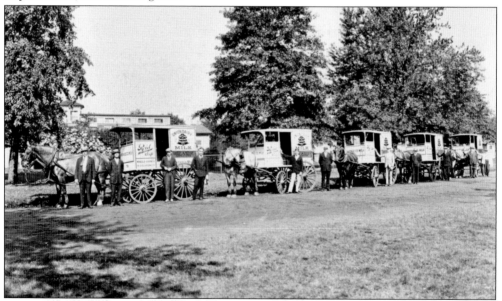

This c. 1915 photograph features a line of well-dressed Reid Union Dairy milkmen parked along a road just inside the entrance gate. Free samples were handed out to children, many of whom attended free of charge on Friday of fair week. It was known as either Children's Day or School Day, and many schools gave them the day off to attend the fair escorted by teachers and mothers.

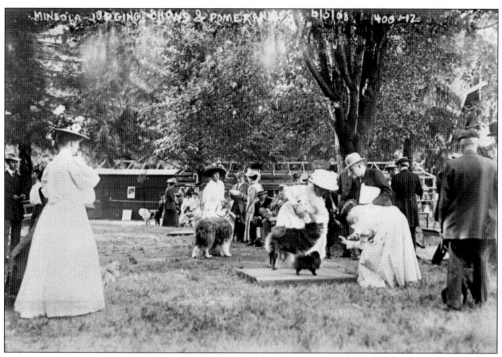

The judging of chows and Pomeranians is a serious affair in this 1908 photograph. The first dog bench show ever held in the country occurred at the fair in 1874. It proved successful and was billed as one of the main attractions for the 1875 fair. It was not held every year, and its reappearance for the 1896 fair was considered a "radical departure" from traditional exhibits by newspapers of the time.

This photograph, also from 1908, features Mrs. Morris Mandy holding a Pekinese named Pou-sa, which was owned by Mrs. J.P. Morgan. The dog shows drew the wealthy society matrons to show off their pricey pooches. Photographs of the owners and their dogs were frequently published in society columns. The events were sponsored by the Ladies' Kennel Association.

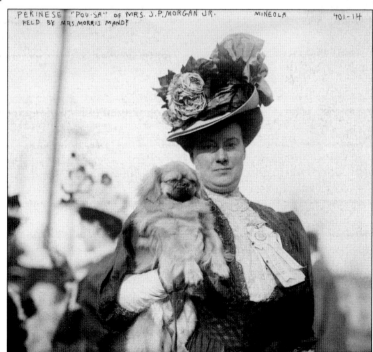

PEKINESE "POU-SA" OF MRS. J.P. MORGAN JR. MINEOLA 401-14
HELD BY MRS. MORRIS MANDY

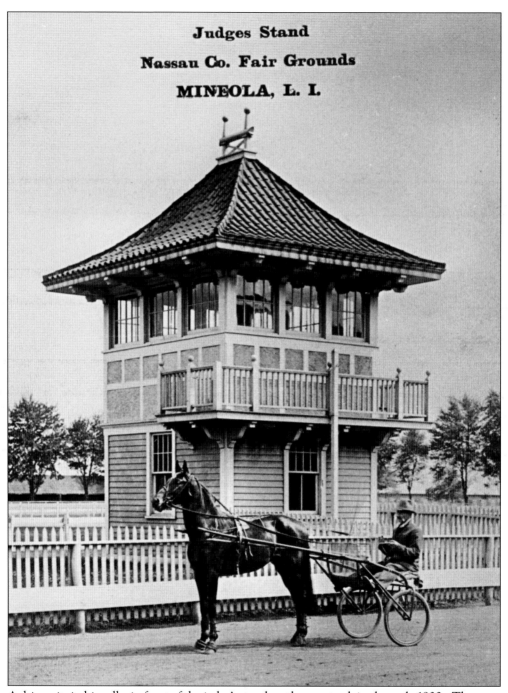

Judges Stand
Nassau Co. Fair Grounds
MINEOLA, L. I.

A driver sits in his sulky in front of the judge's stand on the racetrack in the early 1900s. The state initially had strict laws against racing for money and betting on races. However, public demand was such that eventually the restrictions were lifted, legal racing periods were established, and the state began to take its cut in the form of taxes.

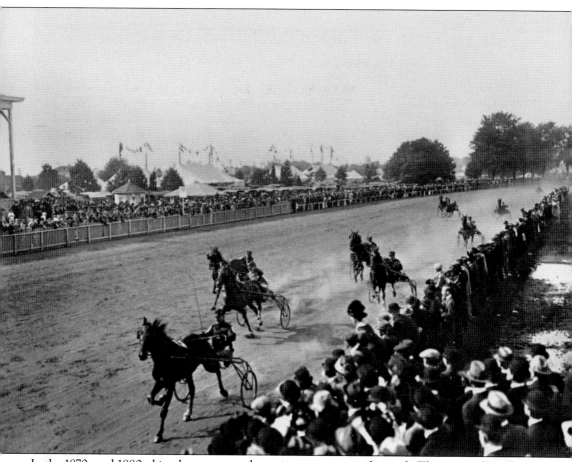

In the 1870s and 1880s, bicycle races were the main attraction on the track. Then came the sulky races, such as the one seen here. These exciting races were popular social events, drawing large crowds each year, with newspaper coverage sometimes spanning several columns. Injury—and sometimes death—occurred to both animal and driver.

The photograph above shows the rear of the grandstand in the 1930s. Below is the view to be had while sitting directly across from the judge's stand in the center. This was not the first grandstand to grace the grounds. In 1891, an existing structure was enlarged by 100 feet. It was still too small, so in 1894, it was removed and a new one erected with a restaurant underneath at a cost of $12,000. This one was destroyed by a fire in 1909. Replacing the burned stand was a third structure that saw Mineola resident Thomas McKee as the contractor. His initial bid of $15,445 swelled to over $20,000 by the time the project was completed in 1910. Seating capacity was now 4,000.

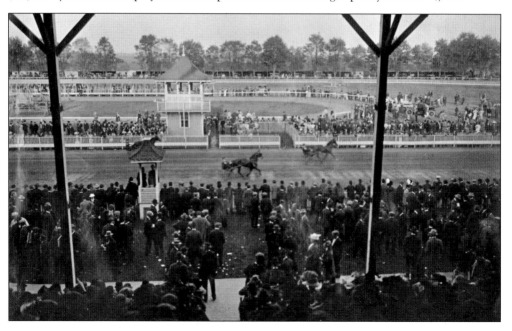

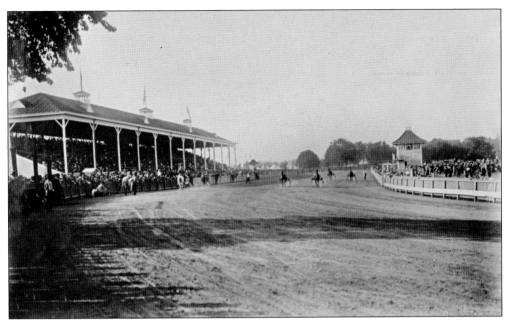

By the time of this 1911 photograph, harness racing was a well-established feature of the fair. Races were contested on the half-mile track of the permanent grounds in 1866, while such races had been held on shorter tracks during the early years when the fair moved around. The National Trotting Association was formed in 1869, with the Queens County Agricultural Society taking membership in 1890.

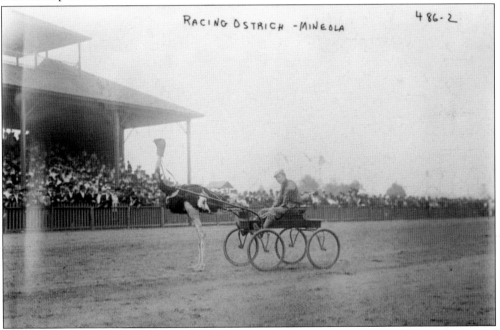

The fair of 1915 saw what was arguably the most unique race in the history of the track. Several local newspapers reported on a race in which an ostrich hitched to a horse cart ran against a horse hitched to a sulky. It is not known which won, but the capacity crowds were well entertained. (Courtesy of the Library of Congress, Prints & Photographs Division, LC-DIG-ggbain-02315.)

Typical of the agricultural society that existed in the early years of the fair, plenty of animals were brought to the fair for contests and to be judged in different classes. For cattle, premiums could be won for the best bull, cow, or heifer of any breed. A $100 premium was offered in 1875 to the farmer with the best head of Jerseys. Individual breeds such as Ayreshires and Herefords also had premiums.

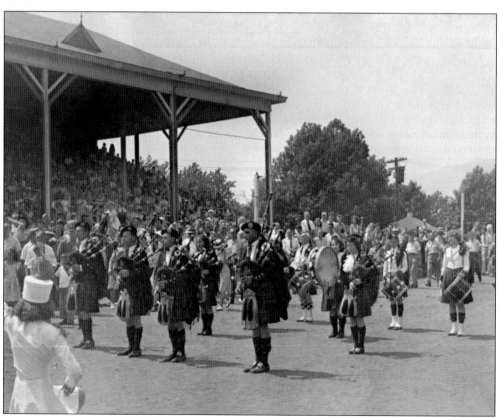

In addition to sulky races, the racetrack hosted many other events as well. These included parades and exhibitions by police and fire departments, military drills, dog races in the summer, the baby parade, and performances by school children. Seen in this 1938 photograph is the Thistle Pipe Band parading past the grandstand.

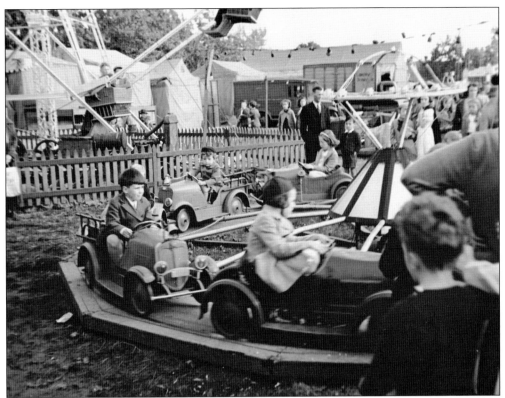

By the 1930s, the trotting races were slowly passing out of popularity. Gaining ground were the midway attractions such as the children's rides, seen above, and the Ferris wheel, below. Added to these amusements were features more typical of a circus. On the schedule for 1938 were acts by the Great Flying Harolds, rollerskating acrobats, the Sensational Four Jacks on their 120-foot high ladders, and Blutch, the famous Hippodrome clown. The man responsible for revitalizing the fair during the difficult economic times was J. Alfred Valentine. He was a graduate of Mineola's public school, a director of the First National Bank of Mineola, and was elected president of the Agricultural Society in 1938.

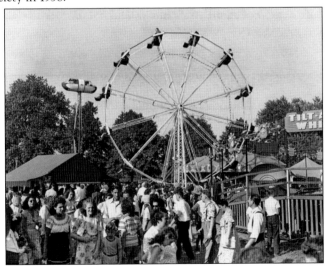

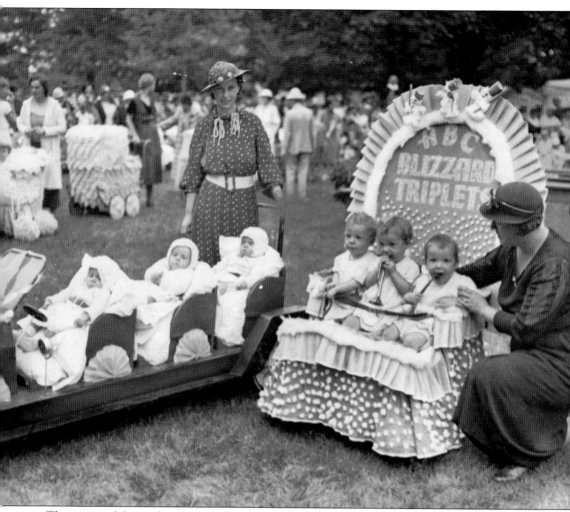

The names of these adorable triplets are unknown, but they were part of the baby show that was first introduced at the fair in 1920. In addition to twin and triplet categories, babies were judged on beauty, size, and strenuousness. A white dress parade was staged in front of the grandstand. The first-place winners were crowned king and queen. The 1929 fair offered 100 premiums and $350 in prize money.

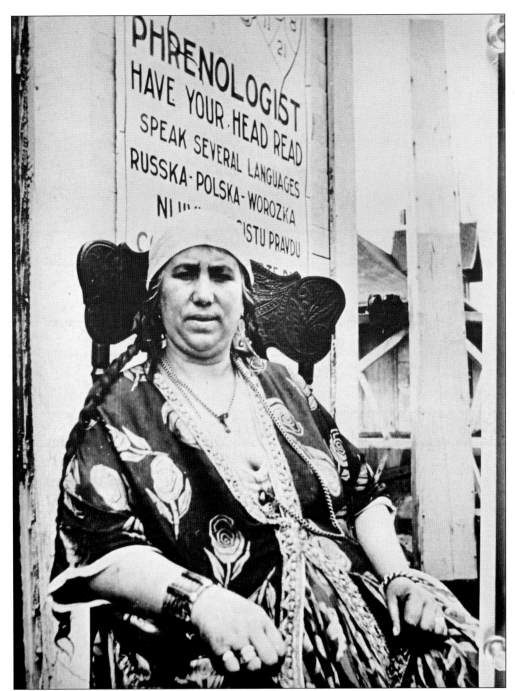

Entertainment could be found both inside and outside the gates. Fairgoers of 1932 could visit fortune tellers, such as this one, who lined the avenues leading to the entrance. Itinerant peddlers, fakirs, and vendors of peanuts, hot dogs, and more were not new arrivals. An 1862 law stated that such people were required to stay back at least 200 feet from any fairground property.

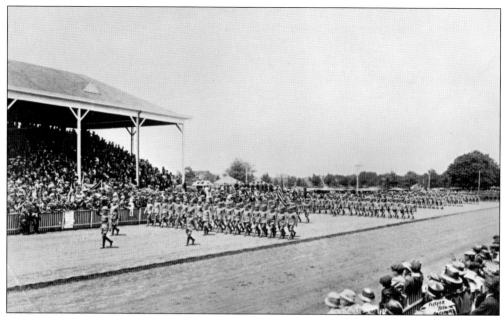

During World War I, soldiers were stationed at nearby Camp Mills in Garden City. This 1917 photograph shows the Nassau County Home Guard as they paraded past the grandstand under the review of Maj. Gen. William A. Mann. The rapid spread of Spanish influenza in 1918 caused the fair to be canceled for the first time in its history, and the grounds were used as a military hospital.

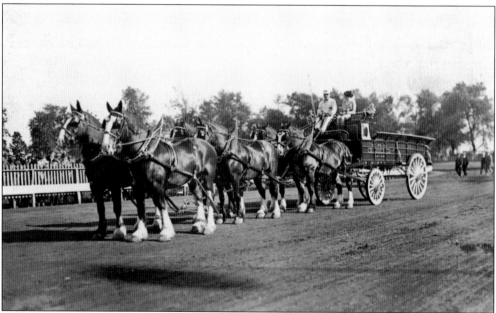

The magnificent draft horses pictured here around 1925 on the racetrack of the fairgrounds belonged to Wilson and Company, a national meatpacking company with a location in Mineola. According to the Sandy Creek newspaper in 1924, the team of six Clydesdales was valued at $100,000 and was entered in the draft horse department of the New York State Fair. The champion horses were fairly well known at the time.

Three

TAKING CARE OF BUSINESS

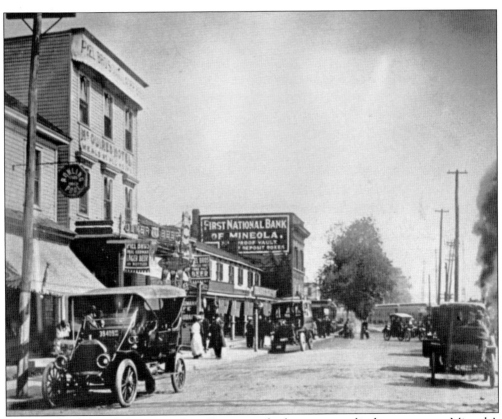

This 1913 photograph by Henry Otto Korten perfectly captures a lively moment on Mineola's Front Street. Pedestrians stroll past McGuire's and Mineola Hotels, the First National Bank, and the local bowling lanes and pool hall. Automobiles, both closed and open, line the curbs. The trolley has just arrived on the corner of Main Street outside the bank, and the train has left the station to make its way toward Oyster Bay.

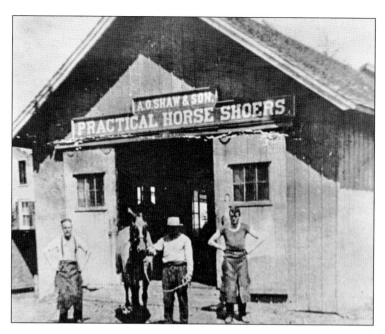

Silas Shaw started his blacksmith business in Mineola in 1850. Following in his father's footsteps, Alonzo O. Shaw opened his Practical Horse Shoers business on Second Street. In its heyday, the shop was well known as the place for shoeing racehorses from the Mineola Fairgrounds and polo ponies of the prominent Westbury families. Alonzo retired in 1920 when it was clear that automobiles were the future of transportation.

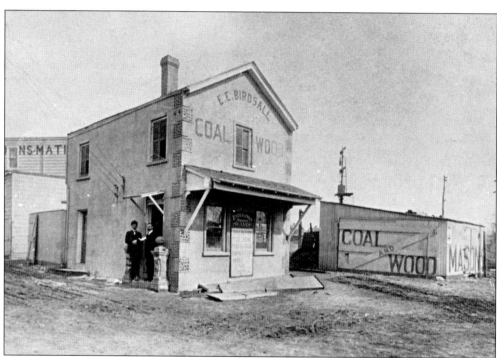

Beginning in 1909, Birdsall Coal Company sold coal, wood, and masonry supplies from its location on Second Street and Willis Avenue. In this c. 1910 picture are two of the three founding directors, local residents Edgar Armstrong (left) and Edward Schmidt. For many years, the company's friendly advertising boasted, "Give us a chance to make you a friend," and "Old friends are our best assets."

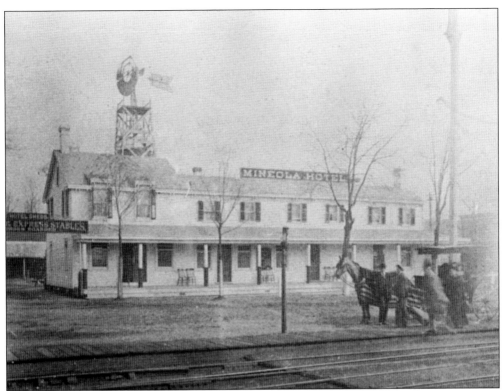

The landmark Mineola Hotel was erected in 1840 across from the newly established railroad station by John A. Searing. Searing served as Queens County sheriff, New York state assemblyman, and US congressman, as well as hotelkeeper. It was here in 1898 (when it was known as Allen's Hotel) that 300 citizens from the towns of Hempstead, North Hempstead, and Oyster Bay met and agreed upon a proposal to separate from Queens County and establish Nassau County. (Courtesy of Photo Archives Center, Nassau County Dept. of Parks, Recreation & Museums.)

One of Mineola's first general stores was owned by Luke Fleet. From the 1840s until his death in 1901, he ran a thriving store and was a much-valued member of the village, serving as a founding member of the Hook & Ladder Company, bank director, Sunday school superintendent, and postmaster. The store and stock were sold to Henry Ehrich for $12,000, and it remained a fixture on Main Street as Ehrich's General Store until its demolition in 1925.

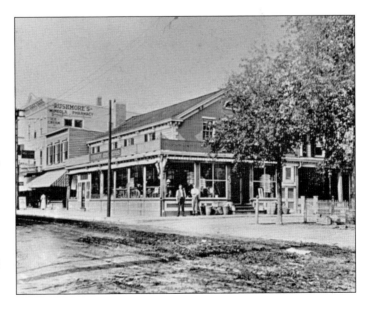

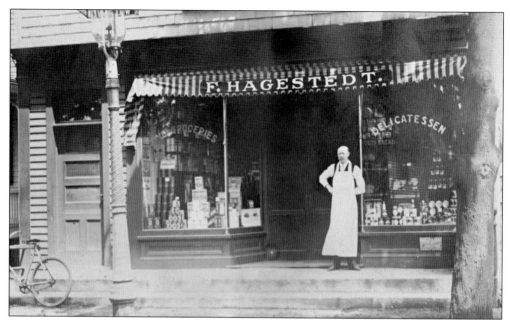

Fred Hagestedt opened his grocery and delicatessen store on September 14, 1912, at the southwest corner of Willis and Harrison Avenues. On opening day, he guaranteed his goods to be the best and offered three cans of Campbell's soup for 25¢. He and his family lived just two blocks away from the store, on Garfield Avenue.

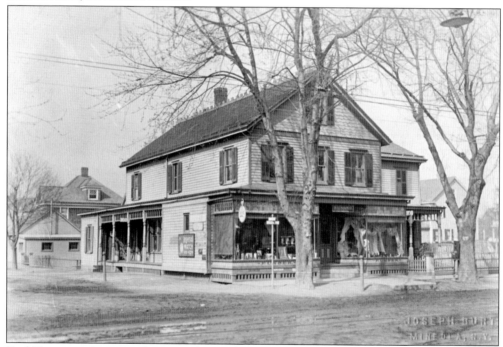

Fred Unser ran this general store at the northwest corner of Willis and Harrison Avenues. One product he sold was the patented Electric Horse Foot Remedy. In 1908, Unser and his 23-year-old son made headlines when they captured two burglars at gunpoint who had broken into the store. The building was destroyed by fire in 1915.

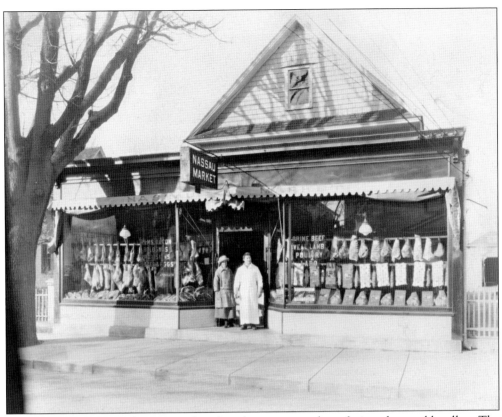

Mineola at one time was home to no less than five grocers and two fruit and vegetable sellers. The fact that they were so numerous was perhaps due to Mineola's close proximity to local farms. One of these stores, the Nassau Market on Second Street, is pictured here in 1924 with owner Ernest Utzweiler in the doorway. (Courtesy of Queens Library, Archives, Joseph Burt Photographs.)

As early as 1888, farmers coming to market in Mineola would stop off at the East Williston Hotel on Jericho Turnpike for a shave and haircut. By 1912, there were five registered barbershops in town within a four-block area. Gus Huber, pictured at far left, kept the men of Mineola looking their best from his Main Street shop. The shaving mugs and brushes along the back wall belonged to the shop's regular patrons and typically had the owner's name embossed on them.

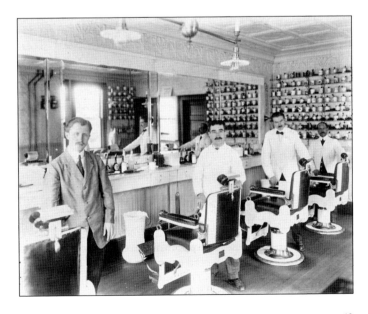

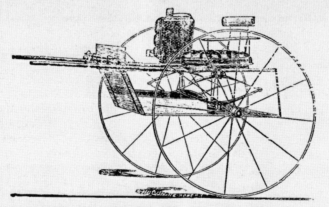

MINEOLA ROAD CART.

C. A. Ellison, Patentee & Manufacturer,

MINEOLA, L. I.

FOR BUSINESS OR PLEASURE IT HAS NO EQUAL.

Mineola became something of a household name through Charles A. Ellison's carriage-making business on Willis Avenue. In 1886, Ellison patented his design for a light and easily handled carriage, the Mineola Road Cart. The two-wheeled carriage featured Ellison's patented spring that would reduce the effects of the horse's motion on the passengers. Orders came in from as far west as Oregon and east to England, where, in 1893, one was sold to Lord Lonsdale, son-in-law of Queen Victoria. Ellison sold the rights to the cart's design to Birdsall, Waite, & Perry of Whitney's Point, New York, but retained the ability to manufacture and sell the carts on Long Island. Additionally, he earned royalties for every Mineola Road Cart sold nationwide.

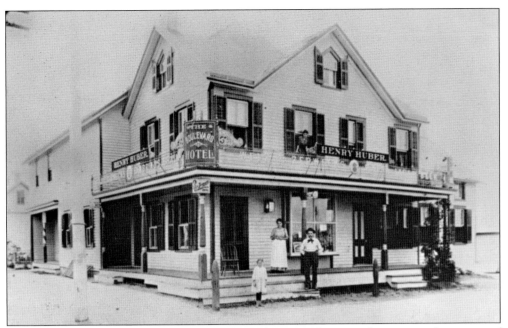

On the north end of town, the Boulevard Hotel occupied a prime location at the corner of Mineola Boulevard and Jericho Turnpike. Both roads were dirt paved well into the 1900s. Henry Huber, shown in this c. 1902 photograph with his wife, Margaret, and daughter Viola, owned and operated several businesses in town, including a grocery and fruit store and an automobile garage. (Courtesy of Queens Library, Archives, Joseph Burt Photographs.)

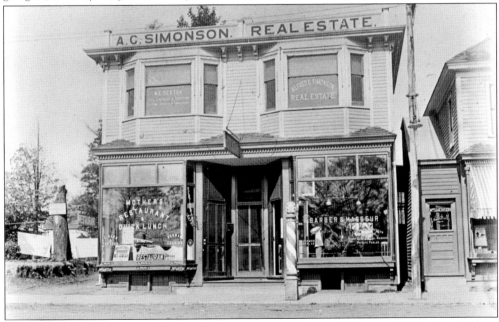

The Simonson Building on Front Street was owned by Alfred C. Simonson. The eldest of 12 children, Alfred established himself in the booming real estate market of Mineola in the first decade of the 20th century. His next youngest brother, William, owned the Mitchell automobile dealership in the shop next door. (Courtesy of Queens Library, Archives, Joseph Burt Photographs.)

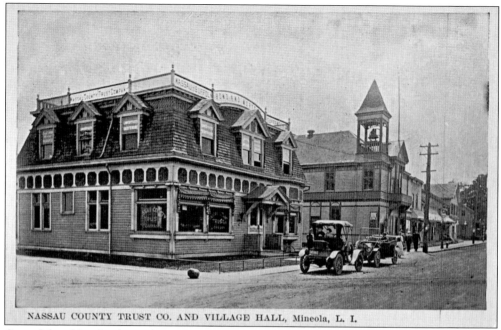

NASSAU COUNTY TRUST CO. AND VILLAGE HALL, Mineola, L. I.

One of the oldest banks in the county was the Nassau County Bank, later the Nassau County Trust Company, which opened for business in Mineola in 1898. Located on the corner of Main and Front Streets, the two-story building also housed the Nassau-Suffolk Bond and Mortgage Guarantee Company. This c. 1915 postcard shows the bank just prior to its move to a grander brick structure on Mineola Boulevard and Second Street in 1916.

Davenport Press printers took over the former bank building in 1923. Founder Louis E. Schwartz began the business as a small print shop and soon expanded into a newspaper publishing plant, producing the *Garden City News*, *Glen Cove Echo*, and *Long Island Sketch*. This is one of the oldest surviving buildings in Mineola and still carries the name Davenport Press, although the business changed from printing to fine dining in the 1970s.

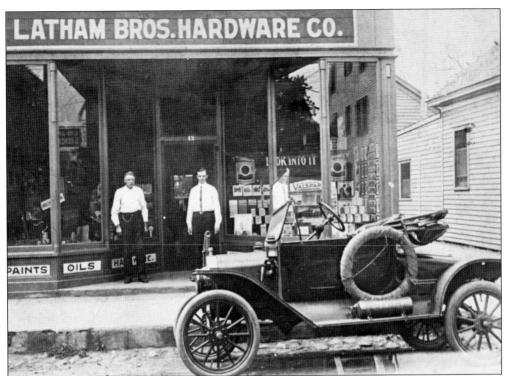

Ralph Latham, originally from Orient, New York, opened a sash and blind business in Mineola on Roosevelt Avenue in 1908. By 1914, he partnered with his brothers Alex and George to establish Latham Bros. Lumber. The business did so well, they kept the office and lumber yard on Roosevelt and established a hardware store on Main Street. The store is pictured around 1918 with Ralph Latham (right) and local builder George Terry.

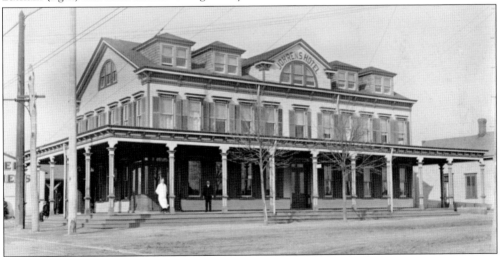

At the turn of the 20th century, Johren's Hotel dominated the corner of Old Country Road and Mineola Boulevard. Trolleys stopped at the corner, and the Nassau County Courthouse was just across the street. It was a popular location for banquets and meetings for such diverse groups as the Nassau Driving Club, Gravy Hunters, and Empire Poultry Association. (Courtesy of Queens Library, Archives, Joseph Burt Photographs.)

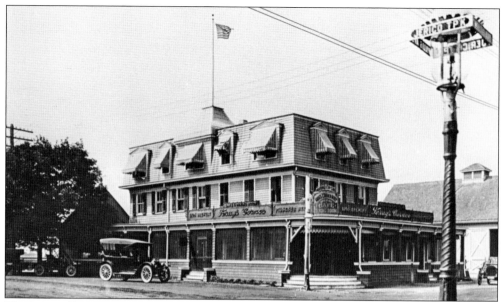

The East Williston Hotel was constructed in 1888 by John Buhler, who was to become Mineola's first president (mayor) when the village incorporated. On the northwest corner of Jericho Turnpike and Willis Avenue, the hotel later achieved renown as the site central to the Vanderbilt Cup road races from 1904 to 1910. In this c. 1915 photograph, it was known as Krug's Corner Hotel. It was a preferred hotel for racers, spectators, and even a young mechanic named Henry Ford.

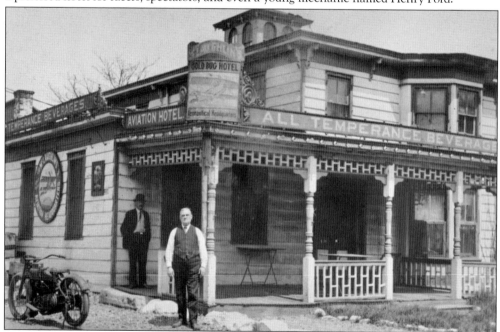

Several hotels, including the Sammis House and the Prairie House, successfully operated on this site at Old Country Road and Main Street. By 1909, it was Pete McLaughlin's Gold Bug Hotel. He unofficially dubbed it "Aeronautical Headquarters" after early aviation pioneers like Glenn Curtiss frequented the hotel and stored their planes in the sheds at the back. McLaughlin is pictured here, in the foreground, in front of his hotel during Prohibition.

The Hotel Nassau was on the west side of the West Hempstead spur tracks and Third Street. Until 1880, this was the private home of George Downing. In 1899, pugilist Jack Downey made the hotel his headquarters as he trained for an upcoming 25-round bout against Pat Sweeney. Theodore Roosevelt also patronized this hotel, as did financiers J.P. Morgan and Clarence Mackay. Hotel Nassau burned down in 1929.

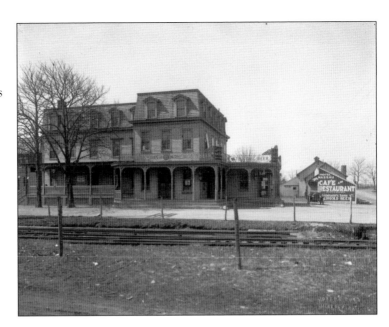

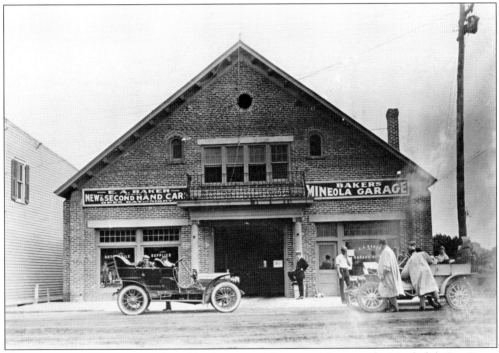

The turn of the 20th century ushered in the automobile age in Mineola. The Vanderbilt Cup Races and Motor Parkway put automobiles in the public's eye, and auto dealerships and garages sprang up to meet the demand. Teddy Baker's Mineola Garage, pictured here in 1909, was located on Jericho Turnpike. Tragically, Baker died that same year when his car swerved off the road and smashed into a telegraph pole. (Courtesy of Queens Library, Archives, Joseph Burt Photographs.)

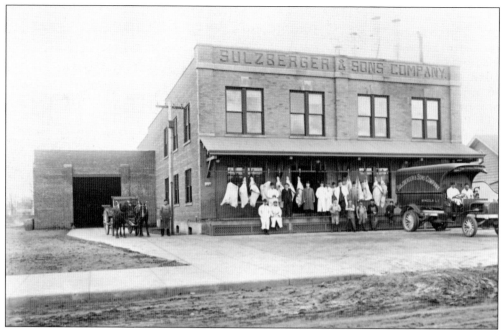

Sulzberger & Sons in Mineola was a branch of the S&S Company, a nationwide meat-packing and provisions business founded in 1853. The property ran from Second Street to the railroad tracks on Front Street. A two-story brick plant was erected, and at its opening in May 1911, it was considered a model of modern efficiency with three on-site smokehouses and its own refrigeration plant. To ensure rapid delivery, the company employed a fleet of the latest motorized vans. (Courtesy of Queens Library, Archives, Joseph Burt Photographs.)

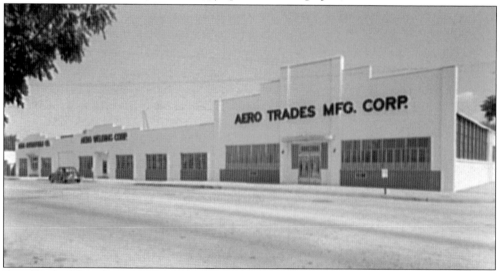

Aero Trades Manufacturing Corporation, a metal fabrication plant, opened in 1931 on Jericho Turnpike in this building, where it still does business today. With Mineola playing an integral role in aviation's early history, the company has provided services to the industry since its inception. Big-name customers include Northrop Grumman, Gulfstream Aerospace, Sikorsky Aircraft, and Texas Instruments. (Courtesy of the Library of Congress, Prints & Photographs Division, LC-G613-72759.)

The *Daily News* cost only 2¢ when this photograph of James Joe Drennan was taken on December 16, 1940. He is seen in Press Building 13 at Roosevelt Field. Drennan Photo Service was a freelance company based in Mineola. According to its newspaper advertisements, it specialized in "studio and album weddings, commercial, legal, passport, chauffeur photos, (and) photostats."

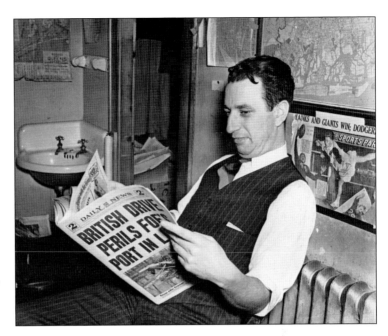

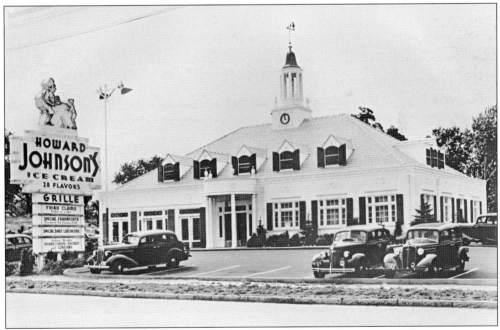

Howard Johnson's restaurant opened in 1938 as part of the company's rapid expansion into the growing leisure market of family automobile travel. Located at the northwest corner of Jericho Turnpike and Herricks Road, it occupied the site that was originally the Queens County Courthouse. In the late 1930s, the area surrounding the restaurant was still largely undeveloped, with only a handful of farms.

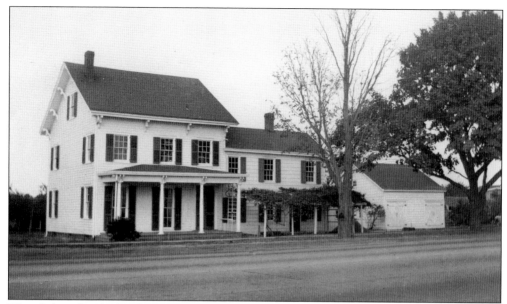

This Colonial-style farmhouse once anchored an 18th-century farm on the corner of Jericho Turnpike and Herricks Road. The 50-acre farm was originally owned by Silvanus Smith, who served as Queens County treasurer and justice of the peace in the early 1800s. This photograph from 1948 shows the farmhouse and one outbuilding directly fronting Jericho Turnpike. The wisteria vine on the pergola was over 100 years old at that time.

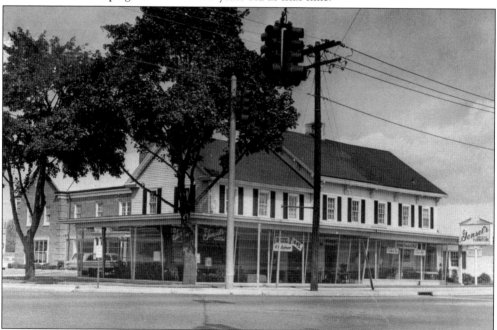

Careful examination of this photograph reveals that Smith's farmhouse is still at the core of this store showroom. Ralph Gensel purchased the property in 1947, renovating the house and outbuildings to accommodate his furniture business, Gensel's Wayside Furniture. The success of the business through the years warranted multiple expansions and additions, resulting in the modern structure seen in this 1960s photograph.

Four

GETTING AROUND TOWN

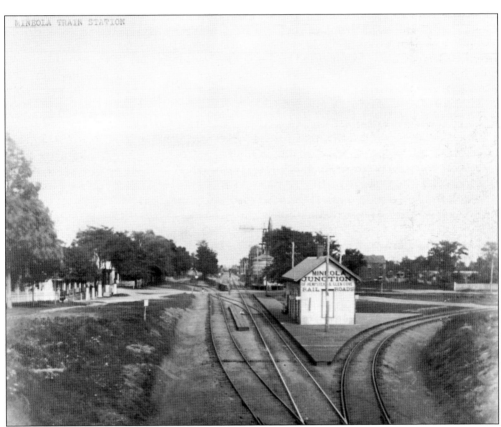

This early view of the Mineola junction looking east dates to 1880. A child riding a tricycle is about to cross Main Street, which is faintly visible perpendicular to the tracks at center. The Glen Cove branch, now the Oyster Bay line, can be seen meandering left of the main line, while the Hempstead branch veers right. According to the US census of 1880, Mineola's population was 313.

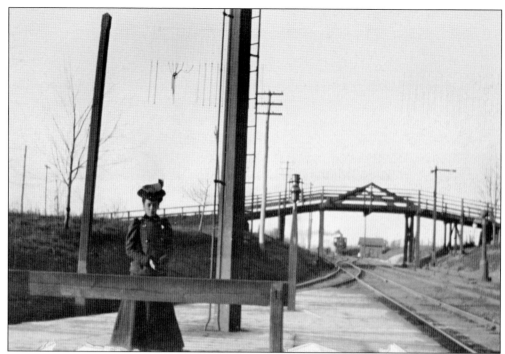

In the photograph above, a fashionable woman poses near the wooden bridge on Mineola Boulevard in 1900. The view is looking west, with an eastbound train just pulling out of the station. The junction curving left leads south to Hempstead. While it is no longer in existence, it was this junction that gave Mineola its original name of Hempstead Branch. The view in the image below looks east. The wooden bridge was first constructed in the 1880s. The iconic junction house visible under the bridge stood in the same location for over 100 years.

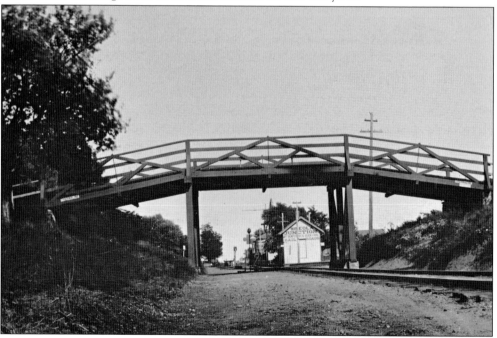

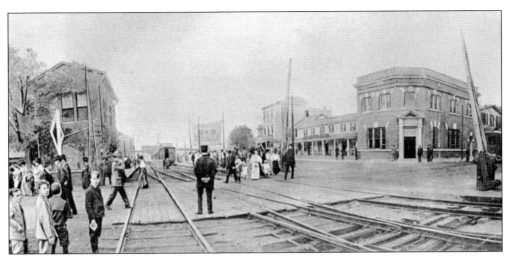

The railroad crossing near Main Street has always been a bustling hub of activity. The raised gates on the right indicate that the train in the center is a westbound train that has just passed and is headed for the station. People are casually crossing the tracks. The intersection on the right is Front and Main Streets, with the First National Bank on the corner.

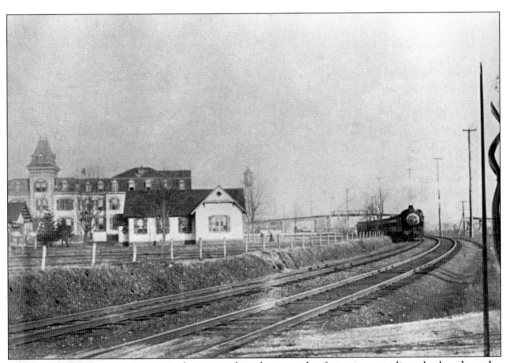

Patience and timing were required to snap this photograph of a train rounding the bend on the Oyster Bay line while a faintly visible trolley passes over it. The trolley is headed to Hicksville. There was some delay in finishing the line as the managers of the Children's Home, seen at left, resisted a trolley traversing their property due to safety concerns. The first trolley over the line ran on January 23, 1909.

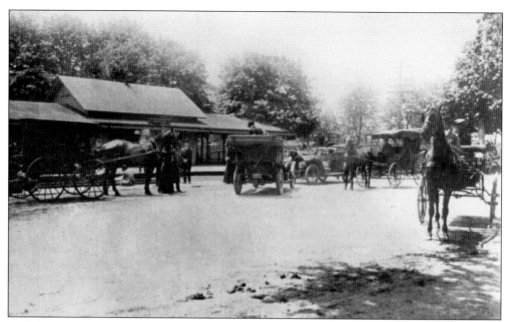

Both horse-drawn and horseless carriages share the road in this turn-of-the-century photograph. The depot in the background on the south side of the tracks was the second one built here in 1883. It was 18 feet by 30 feet, with a platform between 80 and 90 feet. It was considered quite attractive when new, though that opinion would change by World War I.

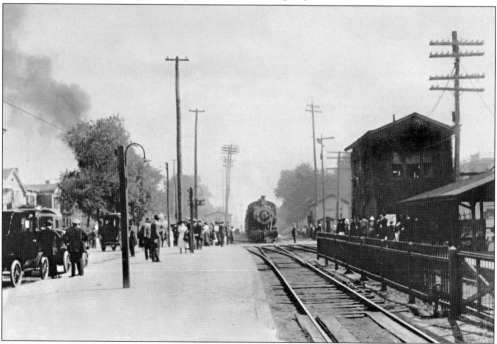

While crowds look on, a westbound engine crosses Main Street as it nears the station in this c. 1910 photograph. Several automobiles can be seen along Front Street. The graceful curves of two electric street lamps sit atop poles to the left of the tracks. A note accompanying the photograph states it was taken during fair time.

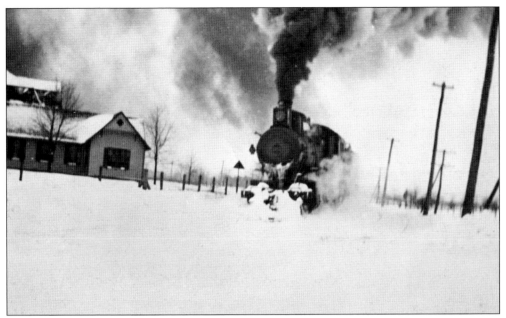

In this 1914 scene, a train belches smoke as it travels on the Oyster Bay branch past the property of the former Children's Home. The view is looking north from Second Street. By 1927, the building on the left was being used as Boy Scout headquarters. Little League meetings also took place there, and it is currently home to the Mineola Athletic Association.

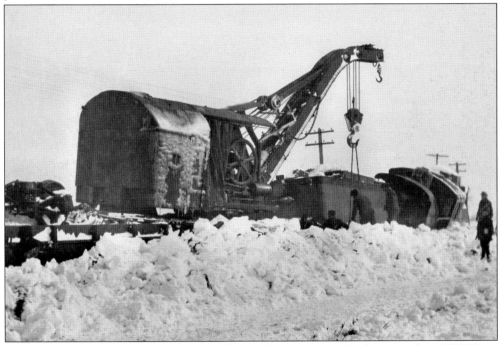

A late winter storm caused havoc on rail lines all across the island on April 4, 1915. Many trains were either stalled in deep drifts as high as six feet in some places, according to newspaper accounts, or derailed. Ron Ziel identified this derailed train as a Joe Burt photograph of engine No. 123 in Mineola.

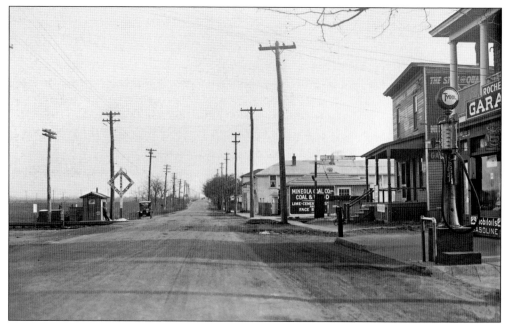

In 1922, Jericho Turnpike was still an unpaved country road. This view looks east past the railroad grade crossing of the Oyster Bay line. Over the years, it was the site of numerous accidents, some fatal. The grade crossing was eliminated when the tracks were raised in 1936. Gasoline was a mere 19¢, according to the sign on the gas station on the right.

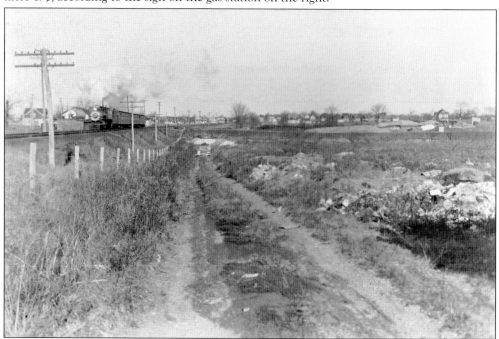

Photographer Joe Burt positioned himself just east of the Oyster Bay branch seen on the left to capture this image looking north from Jericho Turnpike in 1926. The area in the foreground appears desolate in comparison to the homes visible in the distance. Occupying this empty space today is McDonald's and a small shopping center.

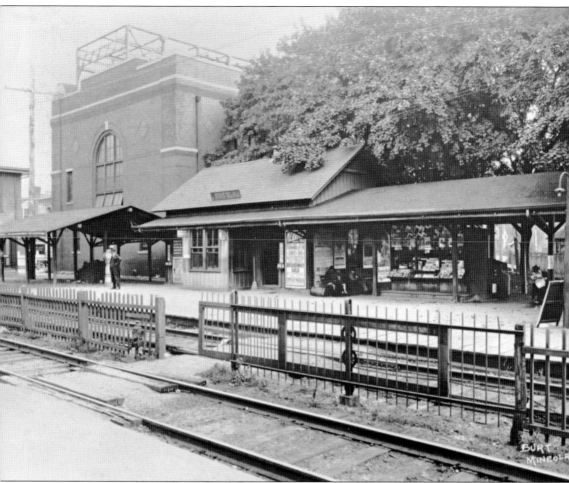

This 1923 photograph shows the station on the eastbound side of the tracks. The taller brick building on the left is an electrical substation built in 1910. This substation supplied the electricity for the Hempstead branch and would also power the third rail once it was extended east from Floral Park. The billboard advertisement is for a boxing match between Jack Dempsey and Luis Firpo on September 14 at New York's famed Polo Grounds. After Firpo sent his opponent tumbling backwards out of the ring, Dempsey returned to win with a knockout in the second round.

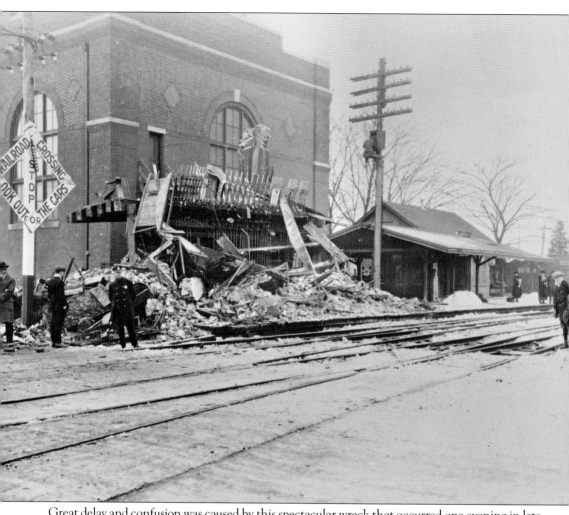

Great delay and confusion was caused by this spectacular wreck that occurred one evening in late December 1922. Empty cars of an Erie freight train heading west jumped the tracks and collided with the switch tower directly in front of the substation. Amazingly, Charles Grath, the tower man who was sitting in the chair seen on the collapsed building's second floor, was unharmed.

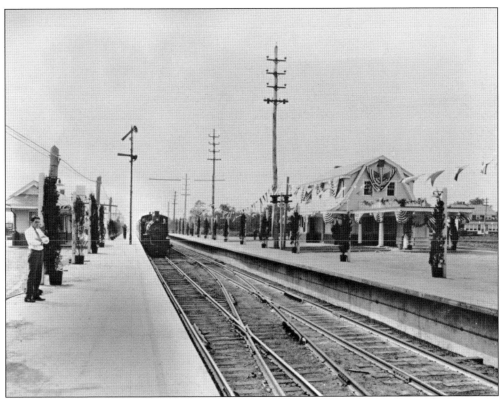

The old station, considered an eyesore by World War I, was replaced with a new station on the north side of the tracks. It opened on September 22, 1923, to great fanfare. Speeches were made, a 50-piece band gave two concerts, and the American Legion hosted a dance in the evening to celebrate. The cost of the station was $68,000. Note the high platforms that were built to accommodate future electrification.

The great blizzard of March 1888, which dumped anywhere from 20 to 60 inches of snow along the East Coast, left many stranded passengers on the railroads. The wedge-style snowplows in common use were virtually ineffective in removing so much heavy snow. The invention of the rotary snowplow, like the one pictured here, greatly improved the situation.

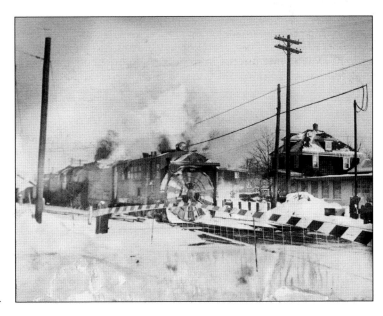

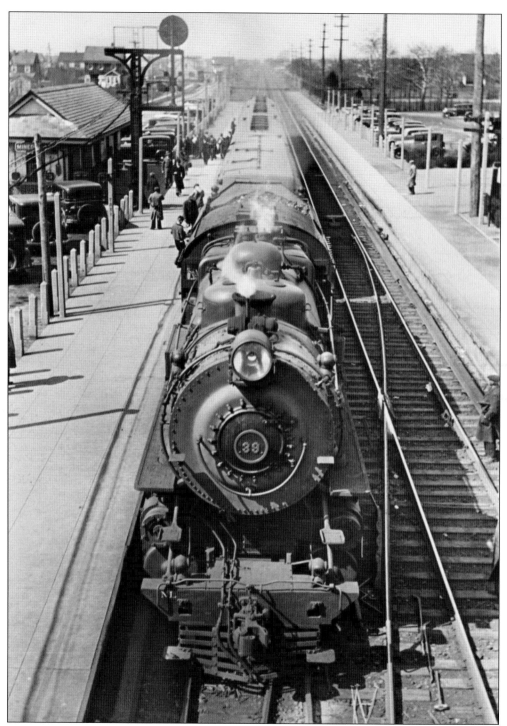

Passengers are busy getting on and off majestic engine No. 39 as it stops in the eastbound station in March 1935. Notice the houses and road in the background to the left of the train where the Intermodal Center stands today. The view looking down suggests the photograph was taken from the Mineola Boulevard Bridge facing west.

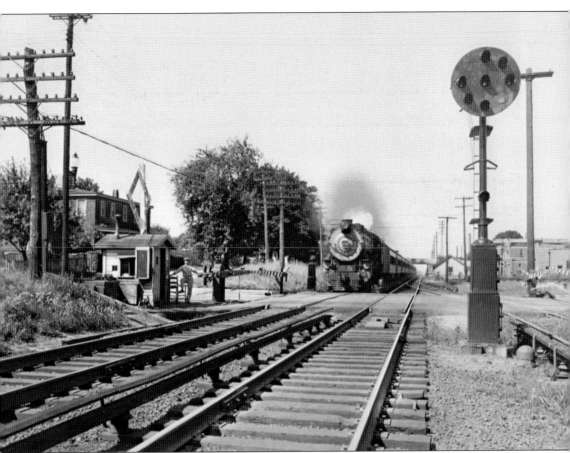

The gates are down at Willis Avenue as an eastbound train crosses at grade around 1946. Note the guard at the gatehouse is not looking at the train but rather up at the signal lights on the right. The gatehouse and residence behind it are no longer in existence. (Courtesy of Queens Library, Archives, Joseph Burt Photographs.)

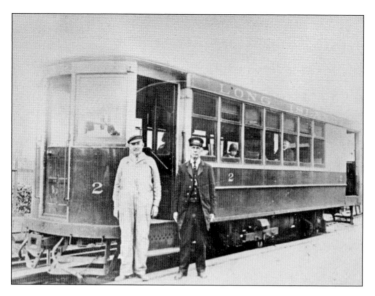

This c. 1915 photograph shows motorman Joe on the left and conductor William J. "Pop" Hughes on the right standing in front of the LIRR trolley that ran between Mineola and Valley Stream. Along with car No. 4, car No. 2 was known locally as a "dinky" and made the seven-mile trip in approximately 23 minutes. Trolleys to Hempstead, Jamaica, and Port Washington also had a terminus in Mineola.

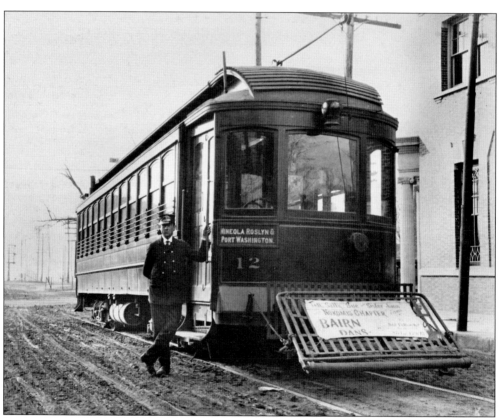

Originally incorporated in 1902, five years passed before the first trolley of the Mineola, Roslyn, and Port Washington Traction Company made a run on November 17, 1907. Many dignitaries and guests took the 17-minute trip from Roslyn to Mineola, including Thomas Albertson, resident and cashier of the Nassau County Bank, and Frank Krug of Krug's Corner Hotel. The fare was 5¢ between stations or 10¢ between Mineola and Port Washington.

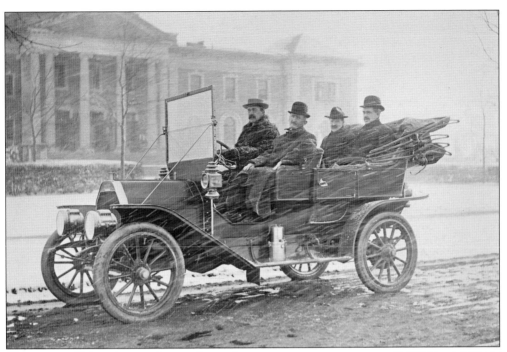

The streets of Mineola were forever changed with the advent of mass-produced automobiles. Gasoline stations, garages, and dealerships began to spring up throughout the village. Resident William Simonson opened up a Mitchell automobile dealership next door to his brother's real estate business on Second Street. Sylvanus Smith and postmaster William McCarthy, also residents, purchased their Mitchell Six automobiles from Simonson in 1910. Frame Motor Company, a Chevrolet dealership located on the corner of Jericho Turnpike and Roslyn Road, was owned by William and Walter Frame. A booming business led to three expansions between 1928 and 1937. An authorized Ford and Zephyr dealer run by George Motz, Mineola Motors Inc. could also be found on Jericho Turnpike. It had a showroom and shop, and was also a parts distributor for Nassau and Suffolk counties. Above, four men are caught in a storm in their open-top touring automobile in front of the Old Nassau County Courthouse in 1912.

New Mitchell

The Six of '16
$1250
A Supreme Factory Achievement

"How is it possible to offer so much value for $1250?" is the question everyone asks when they see the Mitchell Six of '16. This car is not a little Six—it is a magnificent car of long wheel base and sweeping lines.

This value is possible because of its simplicity of design—the Bate two unit construction—and because every part is built at the great 45-acre Mitchell factory under one engineering supervision.

**Study this Mitchell—You'll Long to Drive it
Drive this Mitchell—You're Sure to Own One**

125-inch wheel base; 42 horsepower; large tires, anti-skid rear; Bate two system, with Bate cantilever springs; chrome vanadium steel construction; oversize body; ten-inch upholstering. With seven-passenger body $35.00 extra.

BAYSIDE AUTO COMPANY
Phone 3071 Bayside
BAYSIDE, NEW YORK
AND
WILLIAM SIMONSON
MINEOLA, L. I.

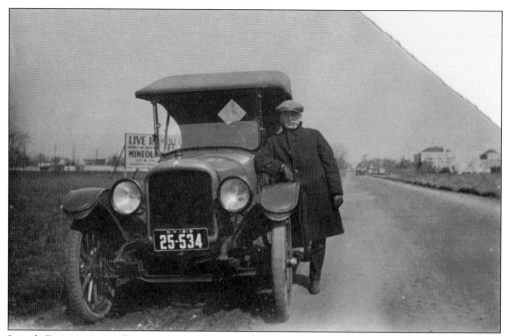

Joseph Foppiani casually poses alongside his vehicle. The license plate indicates that the year is 1919. The courthouse and jail are visible in the background on the right, making this a view of Old Country Road looking east. An advertisement on the left encourages home buyers to come to the area.

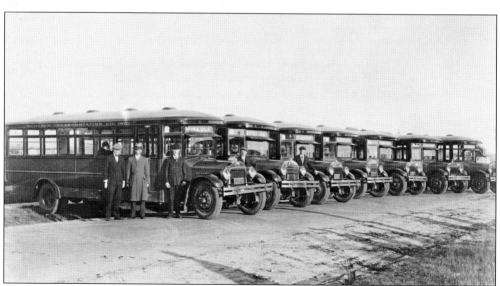

Bus lines were beginning to edge out trolley service by the mid-1920s. This line of seven vehicles from 1927 was owned by the Schenck Transportation Company. Pres. Howard E. Schenck lived in nearby East Williston, while both his mother and brother owned homes in Mineola. A two-week strike of Schenck drivers in 1951 affected 20,000 people, including schoolchildren.

This dashing man seated in his biplane is well-known aviator Glenn H. Curtiss. Prior to becoming a pioneer in the field of aviation, Curtiss built and raced bicycles and later moved onto motorcycles. Curtiss was invited to join Alexander Graham Bell's Aerial Experiment Association, where he designed and piloted Aerodrome No. 3. Better known as the *June Bug*, it won the Scientific American Trophy on July 4, 1908.

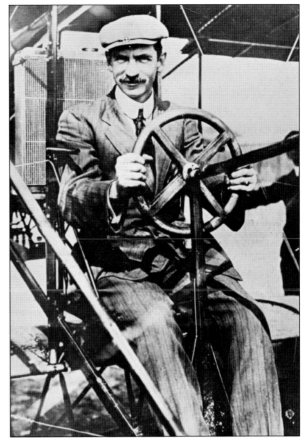

In July 1909, Glenn Curtiss could be seen testing his Golden Flyer aircraft above the Mineola Fairgrounds, pictured here, and Hempstead Plains in preparation for the first international air show to be held in Reims, France, in August. Simultaneously, he also attempted flights for the Cortlandt Field Bishop prize and the Scientific American Trophy, setting a distance record of 26 miles during 55 minutes in the air.

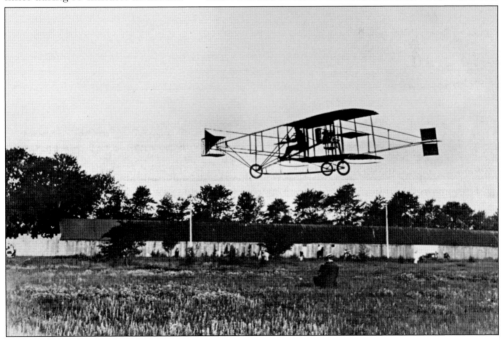

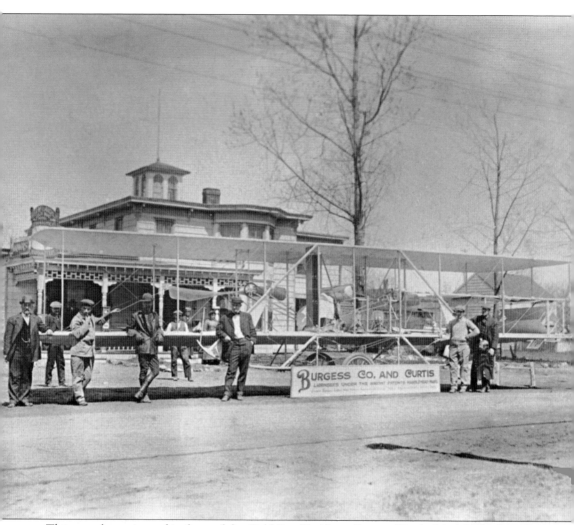

This aeroplane pictured in front of the Gold Bug Hotel is a Burgess-Wright Model F built under license by the Burgess Company and Curtis firm. Its first flight was at Mineola on April 12, 1911, with W. Starling Burgess at the controls. With a wing span just over 29 feet, this $5,000 aeroplane had a top speed of 43 miles per hour. The plane was nearly destroyed the same evening of its debut flight when a raging fire broke out at the northeast end of the Mineola Fairgrounds. It was common practice at the time for aviators to store their planes in the fair's sheds, but Burgess managed to pull his aircraft to safety. Had the fire not been brought under control, an estimated $50,000 in damages would have been incurred due to the loss of the many aircraft stored there.

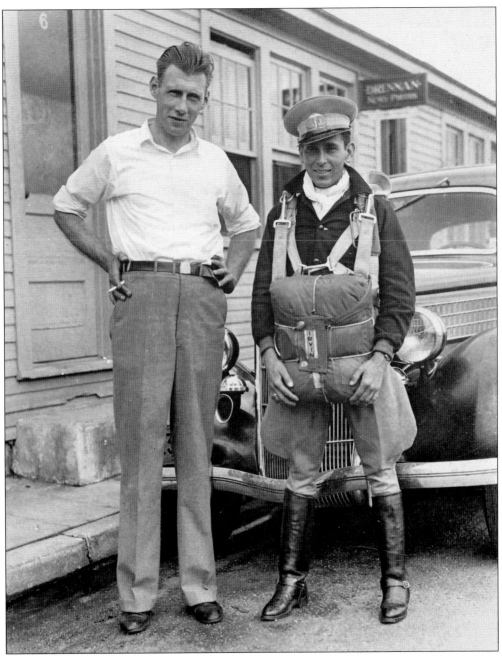

Standing on the left in front of Press Building 13 at Roosevelt Field is professional parachute jumper Joe Crane. Crane was an expert parachutist, having made 425 jumps by age 29. He worked at Roosevelt Field as a ground instructor and parachute rigger, performing special jumping stunts at weekend and holiday air shows. In one 1931 show held over the Mineola skies, he met and shook hands midair with another parachutist, Eddie Wells, which was considered a pioneering stunt at the time. Suited up in jumping gear is an unnamed student of Crane's from South America. Note the Drennan photography sign behind them. Drennan had an office here, along with a business at 156 Main Street in Mineola.

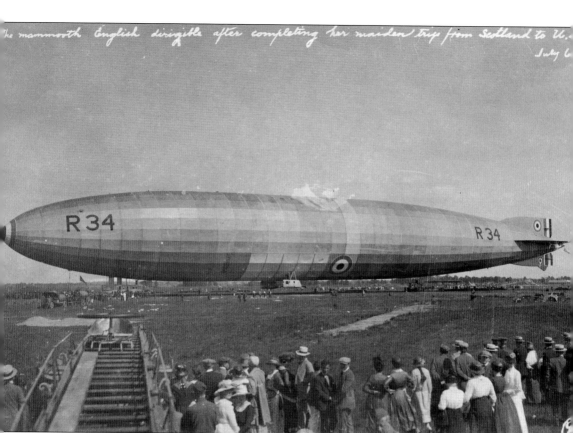

he mammooth English dirigible after completing her maiden trip from Scotland to U. July 6

The morning of July 6, 1919, brought great excitement at Roosevelt Field, then considered part of Mineola. The British-built dirigible R-34 arrived at 8:45 a.m. following a voyage of four and a half days. The historic flight marked the first transatlantic crossing of a lighter-than-air craft. The flight time from East Fortune, Scotland, of 108 hours, 12 minutes also set a new endurance record. (Courtesy of the Cradle of Aviation Museum.)

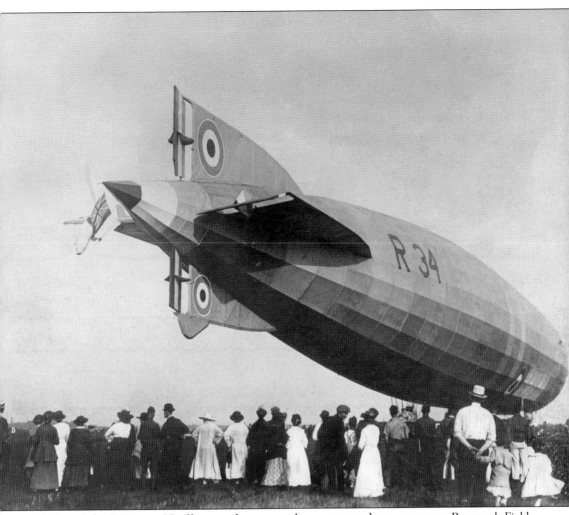

On board the R-34 were 30 officers and crew members, a cat, and one stowaway. Roosevelt Field was readied for the landing with the installation of three new wireless stations, 12 heavy steel and concrete anchors, and grandstands. After battling winds and poor weather most of the way, she made it to Mineola with approximately a half hour's worth of fuel left. (Courtesy of the Cradle of Aviation Museum.)

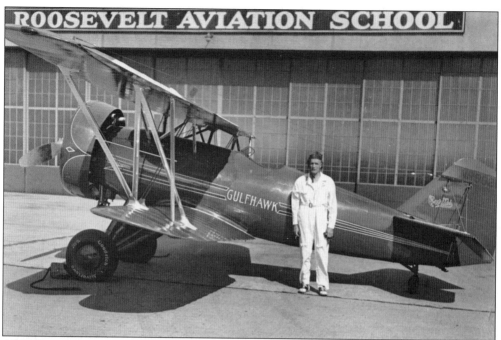

Al Williams, pictured here, was a US Navy test pilot and later, a famous airshow stunt pilot. The Gulfhawk aircraft behind him was originally built by the Curtiss Airplane and Motor Company and was modified by Williams after a crash. It was painted bright orange with a white and blue ray design atop its wings. Gulf Oil Corporation sponsored the plane in airshows between 1933 and 1936.

Captured here in 1937 at Roosevelt Field by Drennan Photo Service is Doris Hammons. She was a stewardess for Transcontinental and Western Airline, later known as TWA. A sad note on the back of the photograph reveals that she was killed in a crash just a few months later while working aboard a TWA flight.

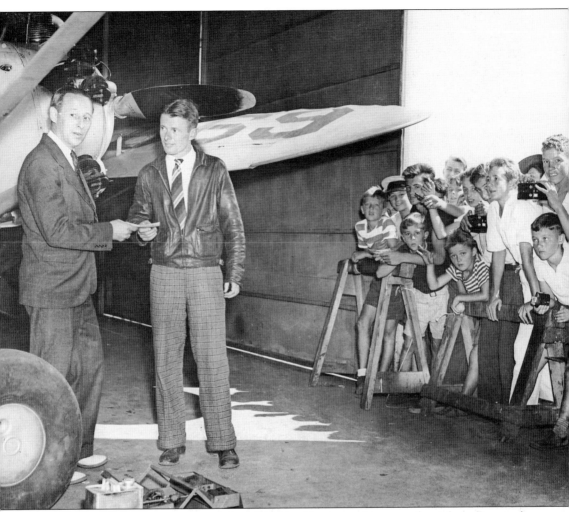

Children gather to get an autograph from Douglas Corrigan, shown on the right at Roosevelt Field after his return from Ireland. On the left is inspector Joseph Boudwin. Douglas took off from Floyd Bennet Field in Brooklyn in 1938, and rather than fly to the Pacific coast as planned, he crossed the Atlantic instead to land in Dublin. His foolhardy but sensational adventure in a nine-year-old airplane earned him the moniker "Wrong Way" Corrigan.

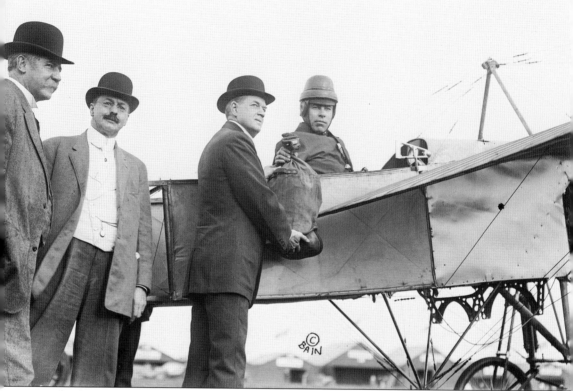

In September 1911, Earle Ovington became the first official airplane mail carrier when he flew with a heavy bag of mail from the Nassau Aerodrome in Garden City to neighboring village Mineola in his plane *Dragonfly*. Spectators were invited to write a postcard to be sent by air on this historic flight. Ovington flew at an altitude of 500 feet and dropped the sack from the open cockpit. The bag's contents of 640 letters and 1,280 postcards exploded on impact. This Bain News Service photograph captures Ovington receiving the mail just prior to takeoff. From left to right are postmaster Edward M. Morgan of New York, unidentified, and postmaster general Frank Harris Hitchcock. Later that year, Ovington accomplished another first when he made a bank deposit by plane. Flying in a Curtiss biplane from the Aero Club of New York, he passed over a section of Garden City and the county courthouse. Lowering his plane, he dropped an envelope containing five silver dollars to an officer of the Nassau Trust Company in Mineola. (Courtesy of Library of Congress, Prints & Photographs Division, LC-DIG-ggbain-09723.)

Five

IT TAKES A VILLAGE

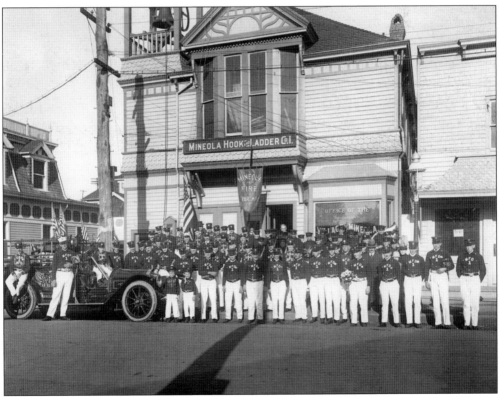

Mineola Hook and Ladder Company No. 1 was formed in 1888 with 23 volunteers headed by Dr. Erasmus D. Skinner. In the spring of 1889, they purchased their first fire wagon and received their first fire call. Fireman's Hall, pictured here, was erected in 1890 on Main and Third Streets. It housed the fire company and the village offices, and its large assembly hall was the site of many club meetings, dances, and fundraising events.

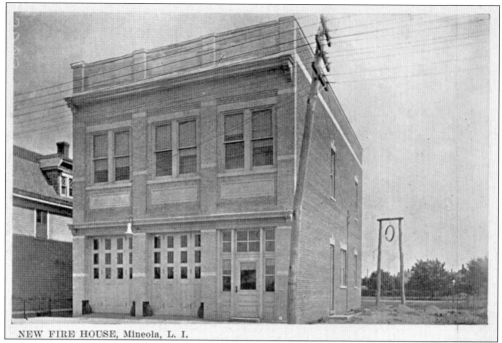

NEW FIRE HOUSE, Mineola, L. I.

A second fire company, Engine and Hose Company No. 1, was incorporated in 1907 with headquarters on Jericho Turnpike. The Village of Mineola reorganized the two fire companies in 1910, creating one volunteer fire department. By 1925, Fireman's Hall was in such disrepair that the village remodeled the Jericho firehouse to accommodate Village Hall and the fire department.

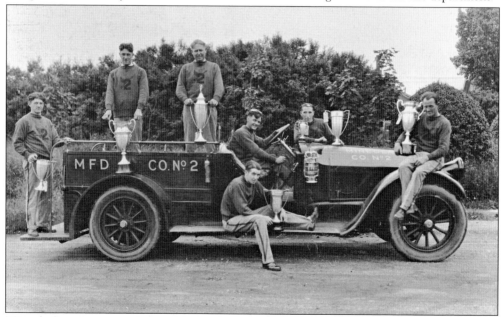

Mineola firemen were active participants in fireman's tournaments. The tournaments tested the firemen's speed and dexterity in handling their equipment in hook and ladder races, hand engine contests, hose races, and ladder contests. In this 1928 Joe Burt photograph, the men of Company No. 2 display their trophies atop their 1921 Pierce-Arrow hose car.

76

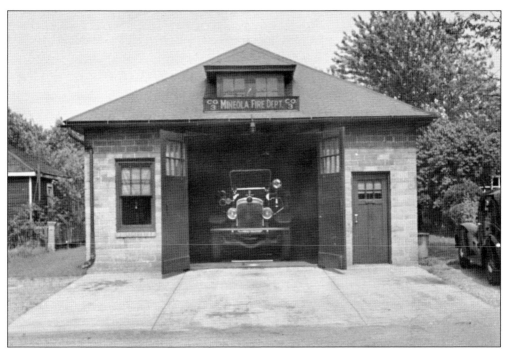

Mineola Fire Company No. 3 is on the eastern side of the village on Elm Place. Incorporated in 1922, its tiny firehouse was erected in 1923 by members of the company in their spare time. Today, the building is home to the Mineola Volunteer Ambulance Corps and is next door to a larger, modernized base for Company No. 3.

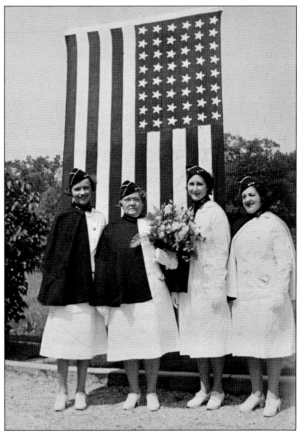

Fire Company No. 3 established a Ladies Auxiliary in 1936. Over the past seven decades, they have given support and assistance to the volunteer company and the community, from providing refreshments at fire scenes, to encouraging volunteer spirit, and hosting fundraising events. This c. 1940s photograph shows, from left to right, auxiliary officers Mary Clark, Louise Beardslee, May Przytula, and Mildred Caso.

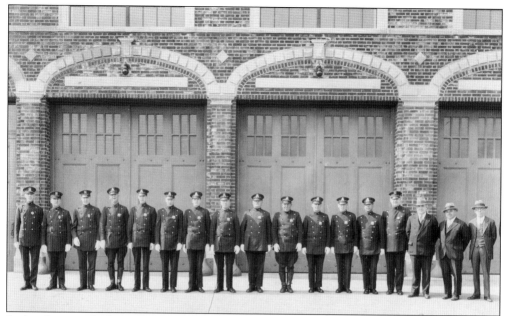

In the photograph above, members of Mineola's police department pose in front of the fire station in the late 1920s. William N. McCormack and Florence Appleby were the first men appointed, in September 1909. A year later, two more men were added to the force patrolling the village, while another eight were appointed in the years leading up to World War I. The board of trustees voted in April 1929 to abolish the village department altogether and join with the county department, which had been supervising the local department for more than a year. The action saved the village approximately $20,000 per year. The photograph below shows the men of the first motorcycle division of the county police in 1912. Pictured on Searing Avenue in front of the Graves Estate are, from left to right, Theodore Magee, Bob Hope, Bill Seaman of Mineola, unidentified, and William Murray. (Below, courtesy of Queens Library, Archives, Joseph Burt Photographs.)

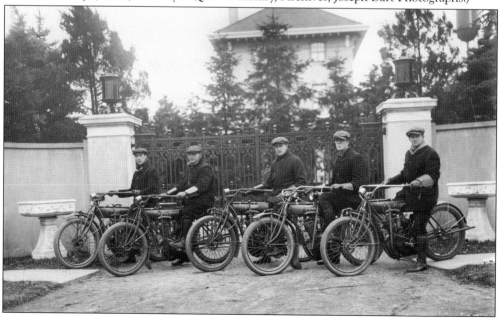

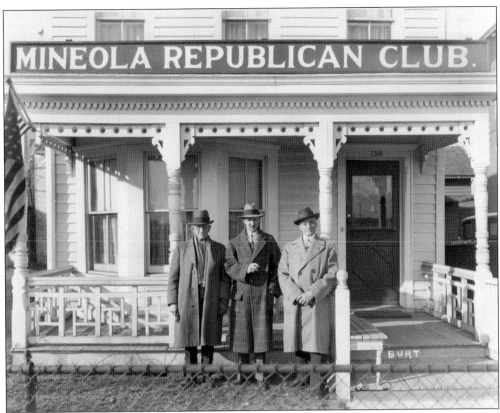

The Mineola Republican Club filed papers of incorporation with the state on January 21, 1928. Less than three weeks later on February 8, it opened the new clubhouse seen here located at 198 Old Country Road. The renovated cottage had plenty of rooms for meetings, as well as social functions. Club president Ralph W. Latham was aided in his efforts to make the clubhouse a reality by the help of many volunteers. (Courtesy of Queens Library, Archives, Joseph Burt Photographs.)

The local Democratic Club in Mineola was led for many years by Philip N. Krug. They held meetings twice a month in the early 1920s. Krug went on to become a leader at the county level as well. The county used as its headquarters the former Andrews residence on Second Street. (Courtesy of Queens Library, Archives, Joseph Burt Photographs.)

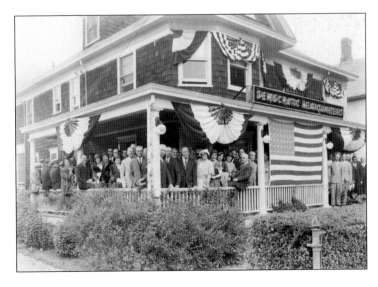

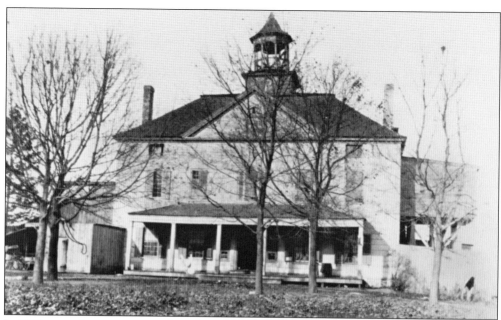

In 1787, a courthouse was erected in what was the geographic center of Queens County: Mineola. At that time, the junction of Jericho Turnpike and Herricks Road was little more than two dirt tracks and a few farms. The building housed the court rooms, sheriff's office, and the county jail. Court sessions frequently took on a carnival atmosphere of general rowdiness, especially with the addition of liquor that was available for sale in stalls set up right out front. The sheriff himself, it was rumored, sold liquor right inside the building. Intoxicated individuals overran the premises, leading one justice to publicly complain that it was the most disorderly court building he had ever attended. After 90 years of service to the courts, the building was refurbished and put to use as the Queens County Insane Asylum. Separate quarters were arranged for men and women, a windmill was erected to pump water to the kitchen and bathrooms, and the surrounding acres were leased to allow the patients to cultivate fresh produce. By 1888, the asylum was overcrowded with 122 patients, and the danger of unsanitary conditions and risk of fire closed the building for good. The property was sold at auction for $800 in 1894. (Both, courtesy of Queens Library, Archives, Joseph Burt Photographs.)

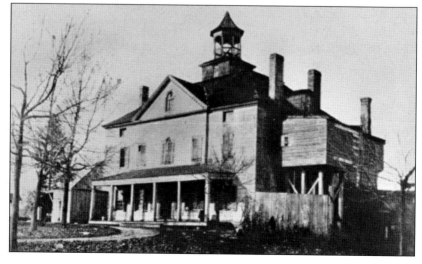

Though it had been discussed for several years, serious talk about the formation of a new county began in 1869 with a meeting at Searing's Hotel in Mineola. Nearly 30 years passed before the separation from Queens County finally occurred. Gov. Theodore Roosevelt, seen here at center facing left, hat in hand, had the honor of laying the cornerstone for the new courthouse on July 13, 1900.

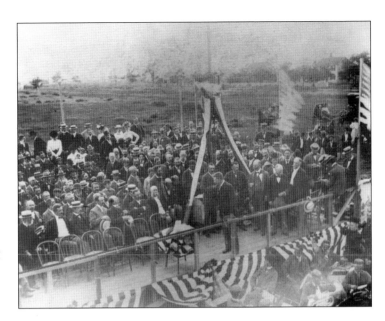

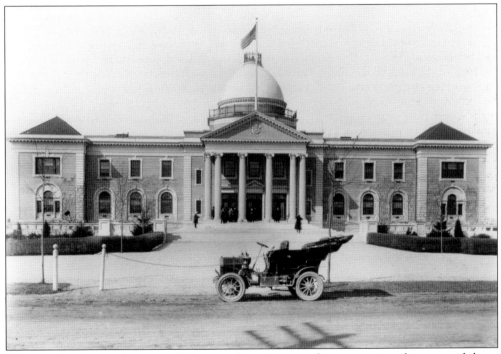

The stately new courthouse could be seen for quite some distance, as its white-capped dome rose high above the flat surrounding area. Although located in today's Garden City, it has a Mineola zip code. Upon the creation of Nassau County in 1898, it was stipulated that the new county buildings had to be located within one mile of the railroad station. Additionally, lawyers and court staff opted to receive their mail from Mineola's post office. Today, this historic building has been beautifully restored and renamed the Theodore Roosevelt Executive and Legislative Building.

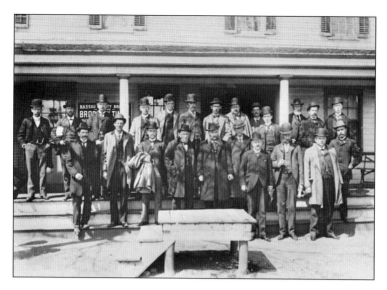

Depicted in this March 1899 photograph are the men who served on the first grand jury of the newly formed Nassau County. They are standing on the steps in front of Allen's Hotel. Before the new courthouse was erected, court proceedings were temporarily held in the truck house of Mineola Hook and Ladder Company No. 1 on Main Street.

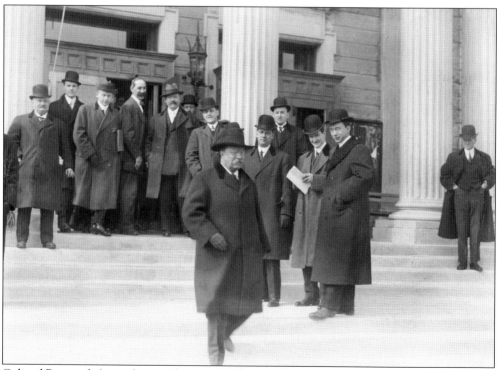

Colonel Roosevelt (center) is seen here in 1912 leaving the courthouse in Mineola that now bears his name. He was summoned there for jury duty in early March. Though his army service meant he could be excused, the *Brooklyn Daily Eagle* wrote on March 4, 1912, "The Colonel stated that he thought it the duty of every citizen to serve on juries when summoned." (Courtesy of Queens Library, Archives, Joseph Burt Photographs.)

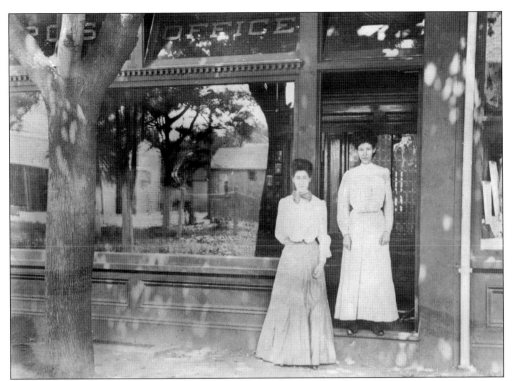

The very first post office for Hempstead Branch, as Mineola was known in 1844, operated from the general store of John Dougherty on the southeast corner of Main and Third Streets. It then moved to Luke Fleet's general store, where a rack of pigeon holes was used to sort the mail. In 1889, postmaster William McCarthy acquired a newfangled outfit from McLane Manufacturing that held 50 call boxes, 6 lock boxes, and a delivery window. This 1910 photograph shows two women standing in front of the post office, which was by then farther north on Main Street.

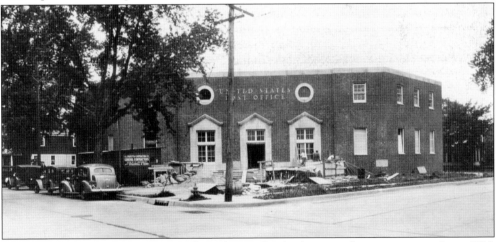

Mineola's current post office is seen here during the final stages of construction in June 1936. The property originally belonged to the Seaman family. It was one of 30 properties visited by federal site agents and was purchased from the Latham brothers for $40,000. It was not until 1919 that the application was made for the numbering of residential homes in order to establish free mail delivery.

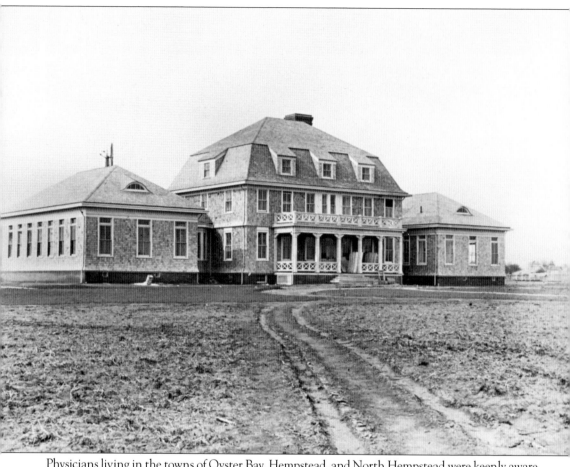

Physicians living in the towns of Oyster Bay, Hempstead, and North Hempstead were keenly aware of the need for a hospital located in the eastern part of Queens County. The Nassau Hospital Association officially incorporated on July 29, 1896, and a search began for the ideal area to locate the new hospital. Centrally located Mineola had seven acres available for purchase close to the fairgrounds and railroad in 1898. Fundraising through private donations, fairs, and benefits garnered $34,000 for construction costs. The grand opening on June 30, 1900, was attended by 600 visitors who marveled at the light and airy atmosphere of the structure, and the thought put into the comfort and well-being of its patients. (Courtesy of Queens Library, Archives, Joseph Burt Photographs.)

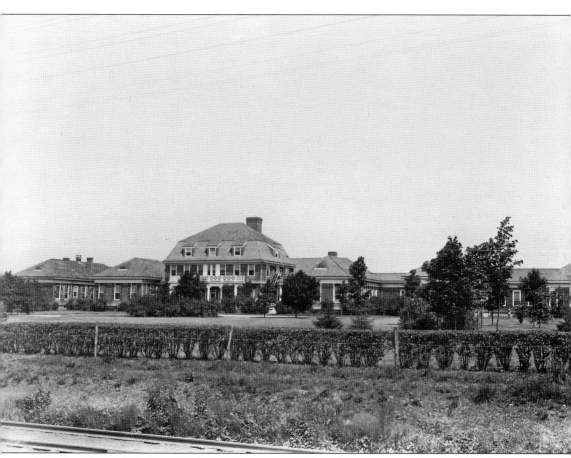

The first floor of the hospital housed separate men's and women's wards with 16 beds each, visitor's reception room, physician's parlor, and the supervising matron's office. The matron's office contained the central telephone system connecting all parts of the building, as well as providing the hospital with outside contact. It was furnished with $300 raised by the young girls of the Mizpah Sewing Class of Mineola.

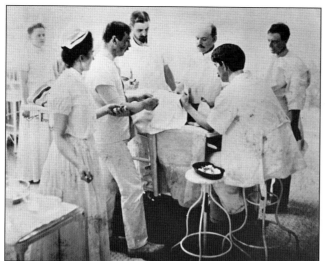

At the rear of the hospital building was a 30-by-40-foot operating pavilion. A stepped viewing gallery on two sides allowed professional staff to observe surgical procedures. Pictured here is one of the hospital's first operations, attended by, from left to right, Drs. Gustav Fensterer, John Hutcheson, Louis Lanehart, Charles Niesley, and John Mann. The nurses are unidentified.

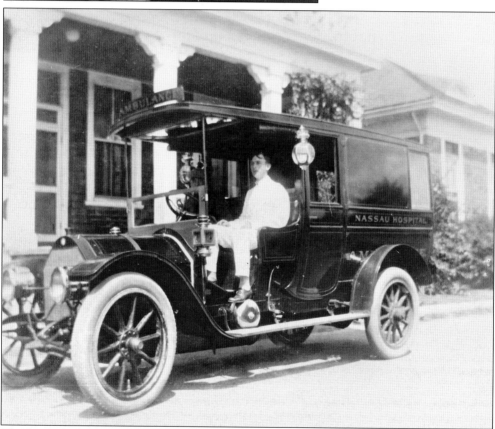

The first ambulance for the hospital was simply a wagon driven by Phil Hubert or Bill Lee pulled by a team of horses. In 1910, Roswell Eldridge donated the 40-horsepower auto ambulance pictured here. The deluxe vehicle was capable of carrying four persons in the rear, a doctor, nurse, and a driver. It was equipped with surgical instruments in specially designed compartments and was electrically illuminated. To ensure a safe journey, the vehicle could not exceed 30 miles per hour. (Courtesy of Queens Library, Archives, Joseph Burt Photographs.)

December 1900 saw the opening of the hospital's training school for nurses. By March 1901, there was a class of seven enrolled with a waiting list for admission to the three-year program. Classes were held monthly, with lectures given by medical and surgical staff members, as well as daily practical bedside instruction. A 1930s-era graduating class of 24 students is seen here.

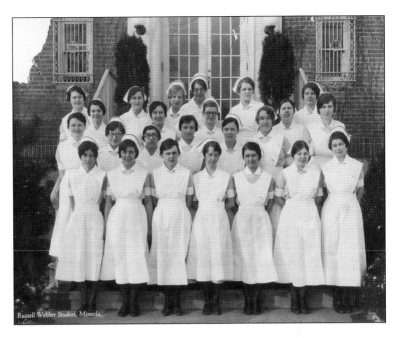

Russell Webber Studios, Mineola,

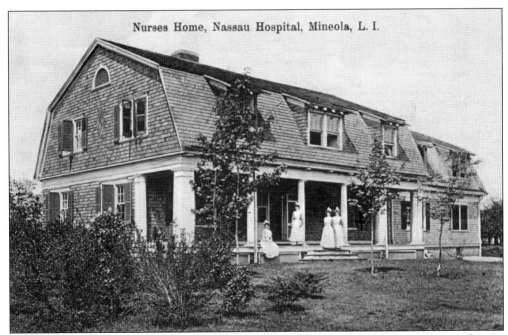

A separate residence for nurses was constructed in 1902 in memorial to William John Mackay Jr., with an addition sponsored in 1907 by Mrs. O.H.P. Belmont. The home had accommodations for 25 nurses in 14 rooms, which were all furnished with pristine white furniture and walls. Nurses were permitted to decorate their personal spaces with color.

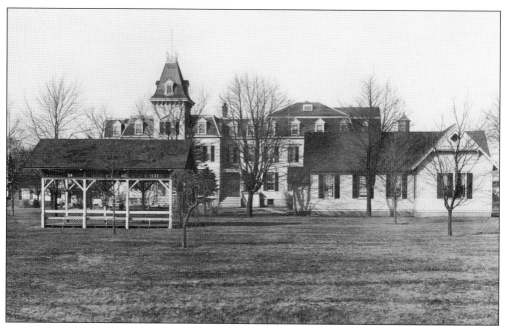

In October 1888, the Temporary Home for Children of Queens County opened its doors to the poor and orphaned of the county. The magnificent building and grounds were constructed at a cost of $12,000 and featured accommodations for 64 children. The three-story building was dominated by a 62-foot tower and windmill added in 1890. The home accepted children ages 4 to 14 acting under its mandate to improve conditions of the children physically, mentally, and morally. Some of the children were adopted out, others sent to work, and still others returned to their homes when circumstances improved. The name changed to Children's Home at Mineola in 1906. Although the building burned and was torn down in 1922, the main grounds and auxiliary building continue serving children today as the Mineola Athletic Association ball fields.

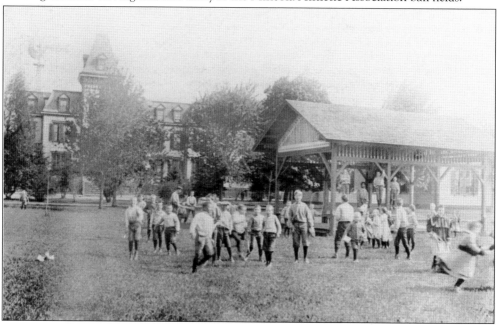

In the 1860s, the wind-powered gristmill at Albertson farm along the north side of Old Country Road ceased operation, and the building was used as a school. The Grain Cistern Academy was reputed to have attracted pupils from across Long Island and New York City. Local students included the four Albertson children—Townsend, Alice, Thomas, and Ethelena—whose father, Thomas, became the first cashier of the Nassau County Trust Company, as well as Anna, Sarah, and John E. Allen. John later became the proprietor of Allen's Mineola Hotel.

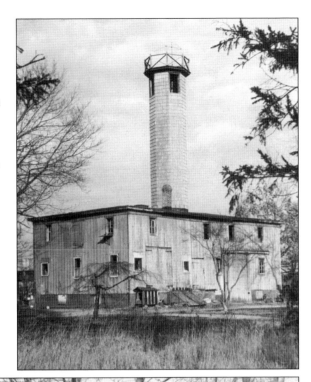

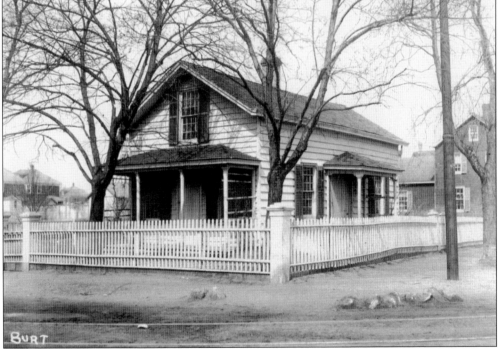

Mineola's first school was built in 1816 and located on the northwest corner of Willis Avenue and First Street. The one-room structure could hold 25 students, with accommodations for a single teacher upstairs. For years, the building was also used for Sunday church services and prayer meetings. (Courtesy of Queens Library, Archives, Joseph Burt Photographs.)

A second, larger school was built in 1876 along the east side of Willis Avenue near Harrison Avenue. School trustees were empowered to raise no more than $1,500 in taxes to pay for the new schoolhouse. Lenora Hubbs was the sole teacher. Within 15 years, additional rooms had been built to accommodate the growing student population, and a total of three teachers were employed. (Courtesy of Queens Library, Archives, Joseph Burt Photographs.)

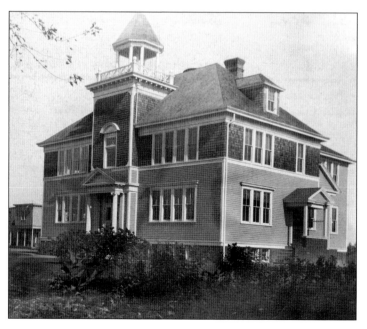

Mineola's rapidly growing population necessitated the construction of a third school in 1900 on Willis and Jackson Avenues. The second-floor classrooms were intended for future expansion, but by 1908, every room was in use, including the principal's office. An addition was constructed that year that doubled the school's size, and a second addition in 1915 doubled it again. The building was replaced with a fourth school on the same site in 2003.

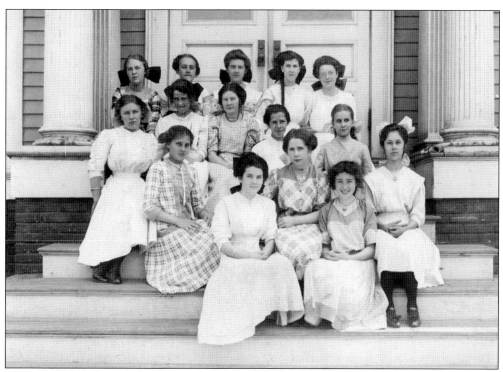

Mineola High School girls pose on the steps of the Willis Avenue School about 1912. Helen Willis and Vivian Free are in the top row, third and fourth from left, and Mildred Armstrong is toward the front at far right wearing black tights. Armstrong made headlines in 1921 when fellow Mineola graduate George Hauser took her on an airplane ride and proposed marriage at 2,000 feet. At 3,100 feet, she answered affirmatively.

This is a photograph of the Mineola High School graduating class of 1913. The graduates are, from left to right, Edna Davis, Lillian Patterson, Florence Thomas, Harry Rockwell, George Hauser, and Roger Patterson. At the commencement exercises, featured speaker Dr. S. Parkes Cadman of Brooklyn expounded on "The Advantages of a High School Education." Thomas trained at Teachers College, returning to Mineola to teach elementary grades.

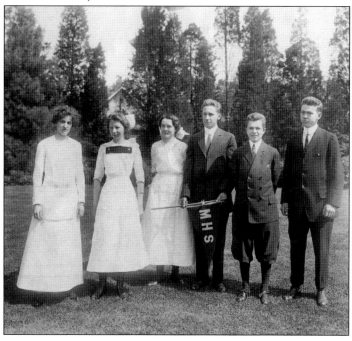

TEACHER'S CONTRACT

I......Florence Thomas......of .Mineola..........
county of..Nassau........ a duly qualified teacher,
hereby contract with the Board of Education of
District number Ten, Town of North Hempstead,
County of Nassau, to teach in the public school of
said district for the term of..ten..consecutive
months, commencing.September.1917.at a monthly com-
pensation of.#70#...dollars and##cents payable at
the end of each month during the term of such
employment.

And the Board of Education of said district
hereby contract to employ said teacher for said
period at the said rate of compensation, payable
at the times herein stated.

Dated, Mineola, N. Y.,.March.14......1917

Florence M. Thomas
..
Teacher

Wm M Faithy
..
HW Andrews
.. } Board
E. J. Armstrong
.. } of
Ehn Schmidt
.. } Education
..

Mineola Public Schools was a fair employer, as evidenced by this 1917 contract with teacher Florence Thomas. Her 10-month school year salary was $700, slightly under the national average of $800. Food prices were not outrageous then, despite the war years, and Thomas could purchase a rib roast for 18¢ a pound, coffee for 19¢ a pound, or five pounds of Quaker oats for 22¢.

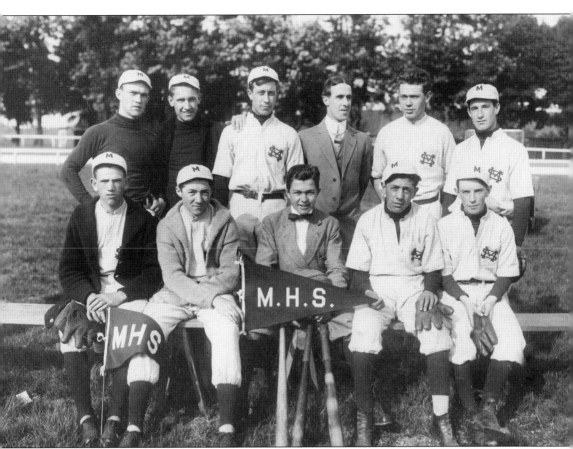

The 1913 Mineola High School baseball team had players whose families were among Mineola's first residents. From left to right are (first row) Jacob Friedman, Andrew Burkard, team manager George Hauser, Jacob Jaffee, and "Trixie" Reardon; (second row) Walter Pike, Harry Rockwell, Frank Krug, principal/coach William W. Wright, Roger Patterson, and Lester Birdsall.

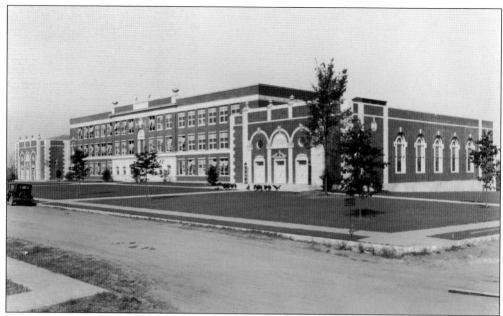

The first two decades of the 20th century marked a population explosion for Mineola. To meet the demand, the district purchased seven and a half acres on Emory Road and drew up plans for a junior-senior high school. When it opened in September 1928, it had 22 classrooms, 3 science rooms, a combination music room and cafeteria, and a home economics suite complete with living room, dining room, bedroom, and kitchen. Seven hundred students attended the school that year, with sixty teachers on the faculty. (Courtesy of Queens Library, Archives, Joseph Burt Photographs.)

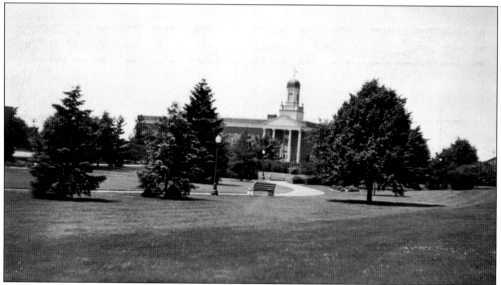

Ten more years saw the addition of Jackson Avenue and Hampton Street Elementary Schools, along with an addition to the high school. Pictured here is Jackson Avenue Elementary School in 1940. Two elementary schools outside Mineola's geographic boundaries also served the district's pupils. Cross Street School in Williston Park opened in 1931, and Meadow Drive School in Albertson opened in 1954.

Alma Clendenny was a powerful, creative influence on generations of village residents. She taught at Mineola High School from 1907 until 1949 and helped to organize the orchestra and music department. She served as choir director at the First Presbyterian Church, assisted at the Mineola Library as a volunteer librarian and trustee, and held offices in several local fraternal organizations. Clendenny contributed much to the cultural enrichment of Mineola as well, writing programs, speeches, songs, and plays, which were performed at the Century Opera House and Mineola Theatre.

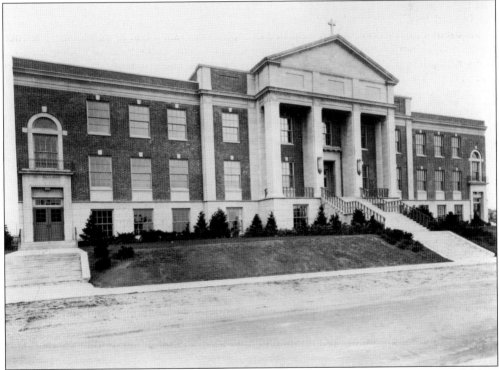

Out of 30 possible locations in the New York metropolitan area, a five-plus acre potato field on Jericho Turnpike in Mineola was selected in 1929 as the ideal site to build Chaminade High School. The Catholic boys' school was the vision of Brother Alexander Ott, a Marianist dedicated to educating young men in a life of faith, community, and leadership. The opening day enrollment of 145 students in 1930 has expanded into today's student body of 1,600 young men. (Courtesy of Queens Library, Archives, Joseph Burt Photographs.)

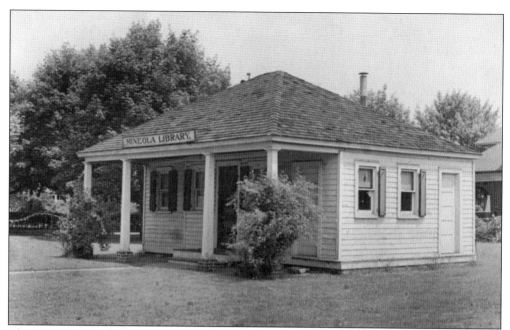

The Mineola Library Association was formed in 1921, and accepted an offer for the free use of a tiny one-room building located at Jericho Turnpike and Mineola Boulevard. This first library opened on February 2, 1922. Carlotta Schmidt was the first appointed librarian who planned on helping only a year or so. She retired 35 years later after working without pay for the first 26 years. By 1925, the library was in search of a more permanent location. Property was purchased slightly south on the same block of Mineola Boulevard, close to Banbury Road. The Little Library building, as it had become known, was relocated in July 1926, seen in the photograph above. The 1930s and 1940s saw increased circulation and membership. Some expansion to the front of the building can be seen in the c. 1936 image below.

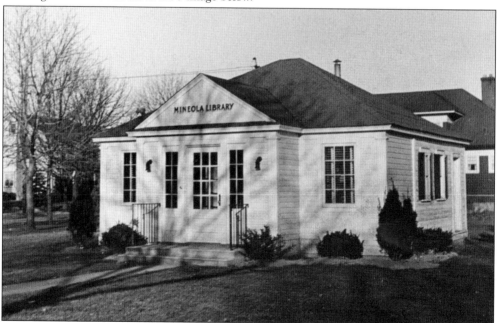

In 1954, the village board decided that a war memorial for the village would take the form of a new and larger library. Land was chosen in the municipal park on Marcellus Road, and bonds were issued totaling $337,500 for construction. Mineola Memorial Library was dedicated on May 30, 1956. On September 22, the final day of Mineola's Golden Jubilee celebration, the Little Library closed forever.

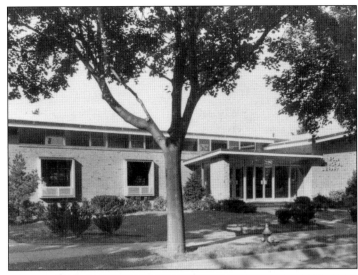

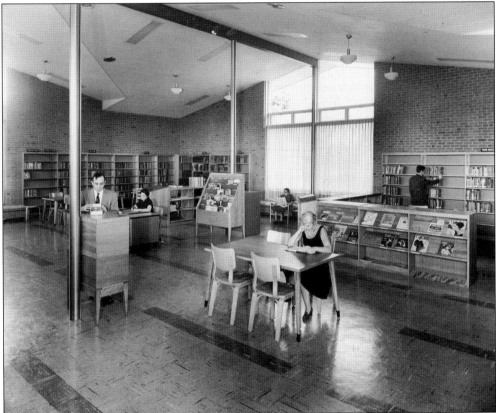

The new library, designed by architects Watterson and Watson, was touted as both modern and functional. In fact, a 1957 library trade publication, The *Pioneer,* titled it "ideal." In this 1957 publicity photograph, library director Martin Erlich browses the card catalog while others utilize the library's collection of books, magazines, and newspapers from the sparsely filled shelves. The design allowed for expansion up to 26,000 books. At the turn of the 21st century, Mineola Memorial Library accommodated four times that amount.

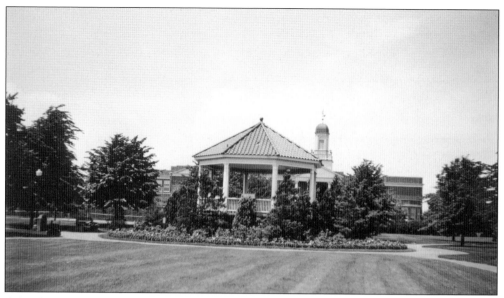

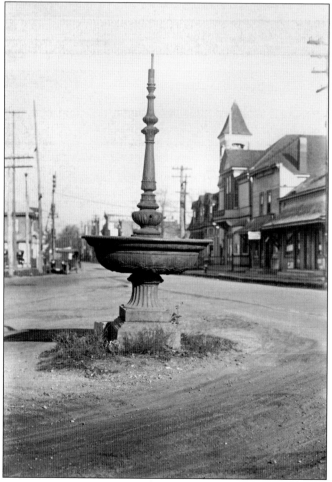

This beautiful gazebo once graced the grounds on the northern end of Memorial Park. Lester Haab, born and raised in Mineola, drew the design while an architect student at Pratt Institute. It was dedicated on November 12, 1932, and 80 years later, it was declared a historical structure in 2012. Unfortunately, over the years, it had fallen into disrepair and suffered damage during storms Irene and Sandy, thus necessitating its demolition.

This elaborate drinking fountain was located on Main Street, one block south of the railroad tracks. It was given as a gift to the village in 1910 by the Westover Branch of the Sunshine Society. The fountain featured water taps for drinking water, and a trough for horses' refreshment. Topping it off was a glass globe that could be illuminated at night.

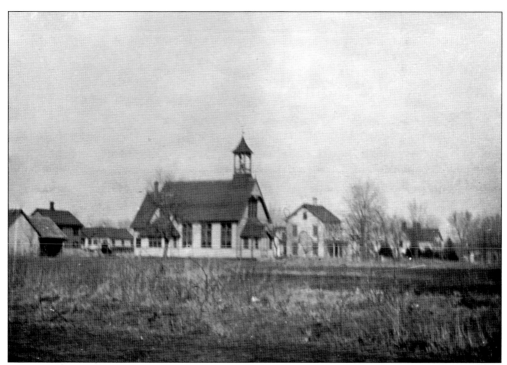

Mineola recognized the need for its own place of worship by 1883. Union Chapel, as it was called, was completed in 1886 on donated land on First and Main Streets. It was nondenominational and could hold 400 worshippers. The Seaman residence, which is visible to the right of the church, was across the street and is the current site of today's post office.

The Mineola Union Chapel Society, which was officially incorporated in 1888, later became the First Presbyterian Church, utilizing the same building for services. A note on the back of this photograph states that a new steeple is being installed, though it is most likely the bell that is being replaced.

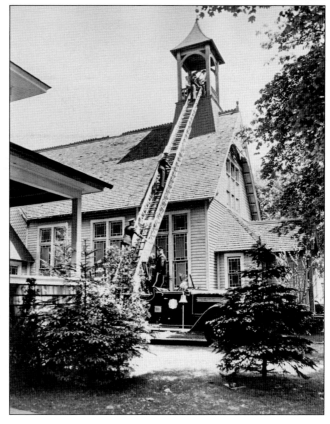

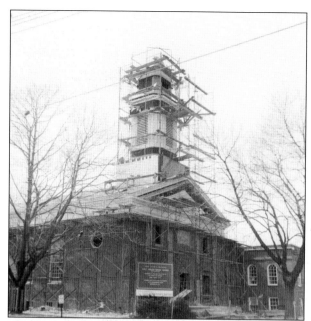

To accommodate a growing congregation, a new and larger church was built in 1948 on the original site of the First Presbyterian Church. Its main entryway was positioned facing Main Street instead of First Street, as in the previous two photographs. The church became the sponsoring organization for Boy Scout Troop 45 in 1946, a relationship that continues to the present day.

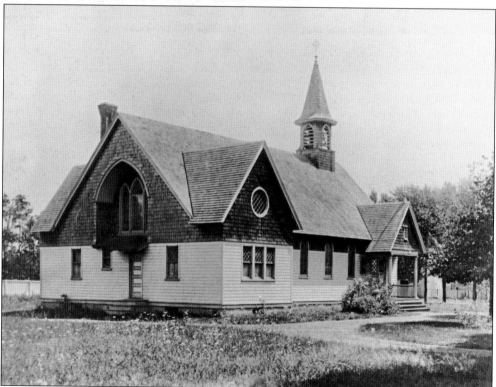

The Episcopal Church of the Nativity began as a mission of the Cathedral of the Incarnation in Garden City. According to the *Brooklyn Daily Eagle*, several thousand people turned out to view the laying of the cornerstone of this quaint church on November 5, 1899. A women's guild of 30 members was soon formed, with Anna Searing as treasurer. The building stands today in its original location.

When the school district vacated its second building, the congregation of St. Paul's German Methodist Church moved in around 1900. The building received a facelift of the stonework, pictured here. The Methodists eventually merged with the First Presbyterian Church, and this structure was used as a youth center before its destruction by fire. (Courtesy of Queens Library, Archives, Joseph Burt Photographs.)

The Lutheran Church of Our Savior stands on the northeast corner of Willis and Jefferson Avenues. The building pictured here was erected in 1935. The house to the right of the church was later moved in order to make room for a school building that, along with the church, is still active today.

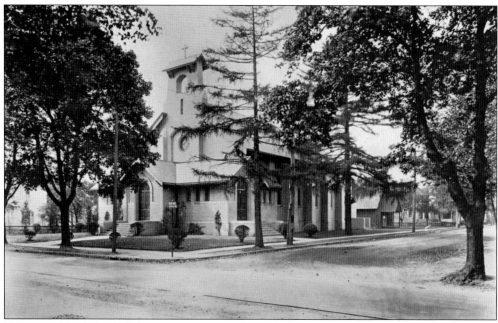

Villagers of Catholic faith began meeting in Allen's Hotel in September 1897. Money was quickly raised and land purchased on Garfield Avenue to build a chapel. The first service held in the new Corpus Christi Chapel occurred in August 1898. Measuring 26 feet by 40 feet, the building cost approximately $800 and contained seating for 200 people. This chapel is the smaller building to the right of the church in the photograph above. Within two years, the debt was paid and the congregation of 16 families celebrated by burning the mortgage. On September 19, 1908, the cornerstone was laid for the church seen in the foreground. This new building doubled the seating capacity, and utilized steam heat and electric lights. The marble altar and stained-glass windows so beautifully decorated for Christmas, seen below, were gifts from the parishioners.

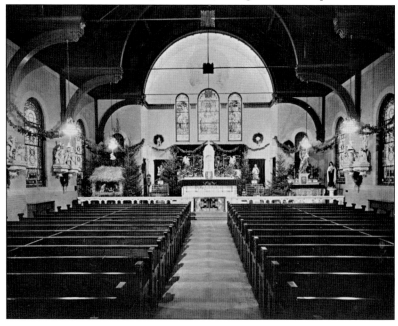

Edward C. Carney was a member of the eighth-grade graduating class of Corpus Christi Catholic School captured in this 1936 Joe Burt photograph. Carney appears in the second row from the back, seventh from the left, just left of center. The church purchased the old Robert Graves garage on Searing Avenue in 1921, reconfiguring the existing building on the property. The Dominican Sisters of Amityville established the school in 1922, with 125 pupils in grades one to four. By 1925, enrollment was up to 250 students. (Courtesy of the family of Edward C. Carney.)

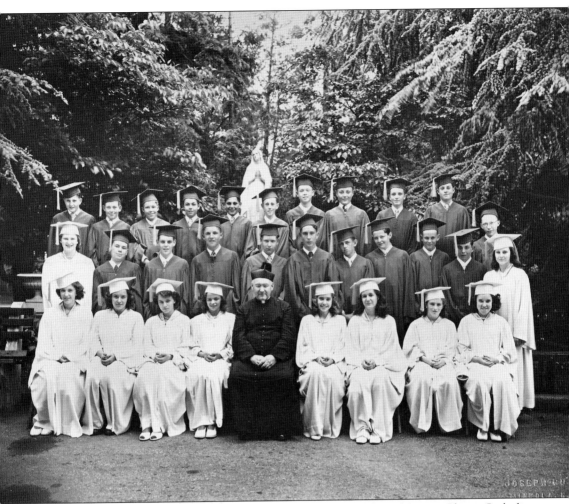

Edward C. Carney was a member of the eighth-grade graduating class of Corpus Christi Catholic School captured in this 1936 Joe Burt photograph. Carney appears in the second row from the back, seventh from the left, just left of center. The church purchased the old Robert Graves garage on Searing Avenue in 1921, reconfiguring the existing building on the property. The Dominican Sisters of Amityville established the school in 1922, with 125 pupils in grades one to four. By 1925, enrollment was up to 250 students. (Courtesy of the family of Edward C. Carney.)

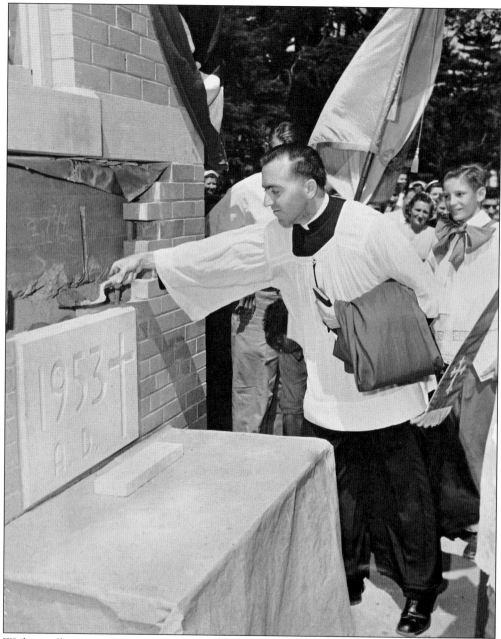

With enrollment straining the capacity of the original school, a new building was necessary. Rev. Vincent Hagan is seen here helping to lay the cornerstone and bless the work. Another addition was later made to the building before the school finally shut its doors in June 2010. Apartment buildings are now planned for the space.

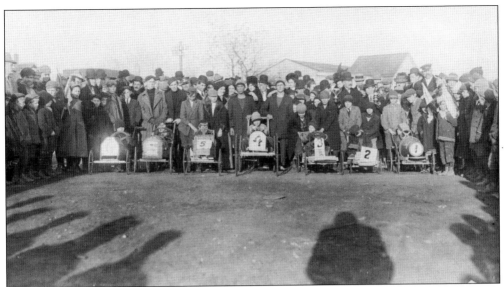

A sizeable crowd has turned out along Old Country Road at the corner of Main Street to witness Boy Scouts racing in their homemade vehicles around 1930. Troop 45 in Mineola was first chartered on June 9, 1921, with the Civic League of Mineola as sponsor. They are still an active troop in the village today.

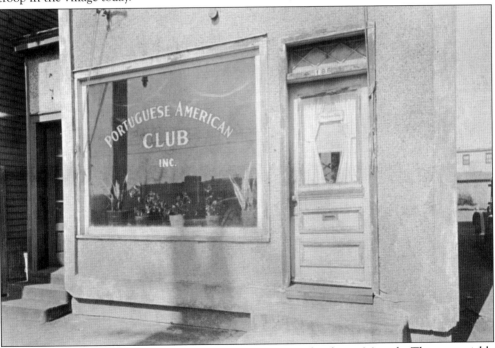

The promise of work in the Depression years drew Portuguese families to Mineola. The men quickly established themselves in the building trades, construction, and road crews. By 1936, a total of 52 residents of Mineola of Portuguese heritage founded the Portuguese American Club. Their first headquarters, pictured here, was a storefront at 186 Front Street. Later moves put them in their present location, the grand hall on Jericho Turnpike. Today, the club has close to 500 members and contributes to numerous Mineola-based charitable and volunteer organizations.

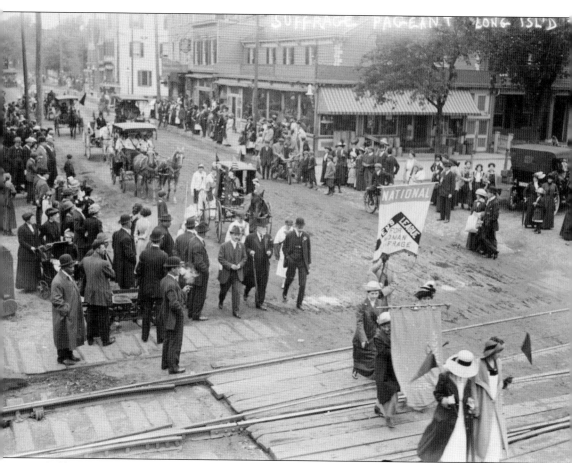

Suffragists from both Nassau and Suffolk Counties gathered in Mineola on May 24, 1913, to stage a mini pageant. A parade wound its way through Main Street, then proceeded down Mineola Boulevard south on its way to Hempstead. Participants are seen here as they cross the tracks on Main Street after passing Ehrich's store with its striped awning. At the head of the parade is the oldest living suffragette on Long Island, Rhoda Glover, 90 years old, riding in a horse-drawn carriage. (Courtesy of the Library of Congress, Prints & Photographs Division, LC-DIG-ggbain-12925.)

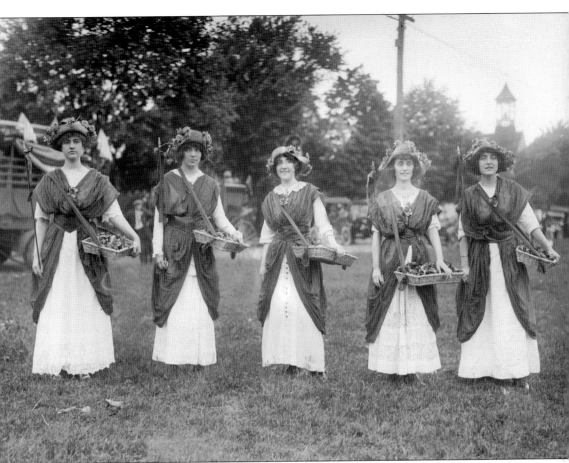

A Maypole dance was held once the procession reached Hempstead, in which these colorfully dressed women participated. Wrapping up the event were speeches in the evening, after which automobiles were sent off with activists making even more speeches as they passed through towns in every direction. (Courtesy of the Library of Congress, Prints & Photographs Division, LC-DIG-ggbain-12930.)

Roger Williams Patterson was a Mineola High School graduate in the class of 1913, working as a Town of North Hempstead clerk when he was drafted on September 4, 1917. Training as a pilot in Princeton, New Jersey, and later in Park Field, Tennessee, he met an untimely death at age 23 on April 23, 1918, when he fell after losing control of his airplane. He resided on Harrison Avenue.

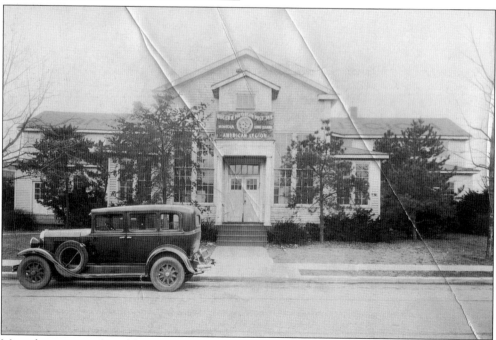

Mineola veterans of World War I formed an American Legion Post in August 1919. They named it Roger Williams Patterson Post No. 349, honoring the first young man from Mineola to die in the war. Interestingly, it was a sister of Patterson, Ella P. Littlejohn, who won the bid to pour the concrete foundation of the building in March 1922 after another brother, Joseph Patterson, defaulted on his bid.

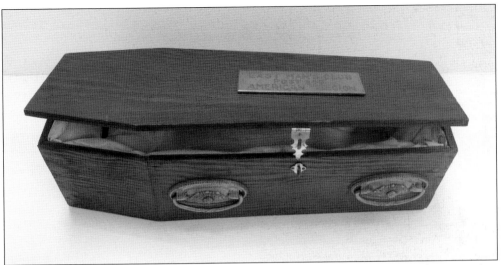

In 1937, a total of 44 World War I veteran members of the Patterson Post formed a group they called the Last Man's Club. At their annual dinner, chairs would be draped in black to represent those men who had passed. The last surviving member received a bottle of brandy kept in this miniature casket. The family of Edward L'Cuyer, secretary and next-to-last man alive, donated the empty casket to the Mineola Historical Society in 2017.

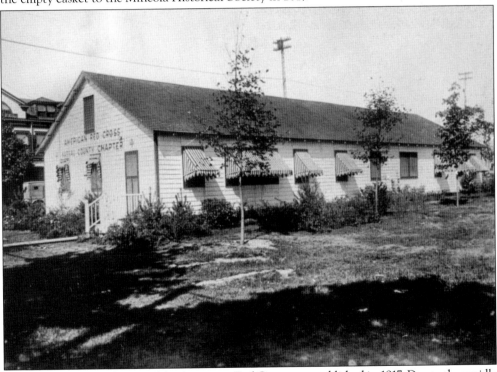

The Nassau County chapter of the American Red Cross was established in 1917. Due to the rapidly growing demands of the organization's work, a building serving as headquarters for the county was erected in 1918 in Mineola on the southeast corner of Old Country Road and Franklin Avenue directly opposite the courthouse. It was considered quite modern with its large reception hall, offices, committee and instruction rooms, and more.

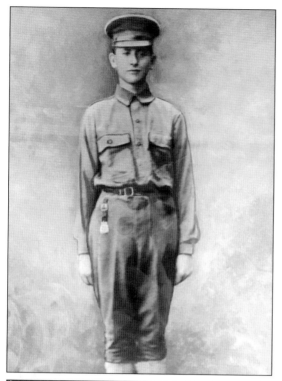

Mineola's Veterans of Foreign Wars Post 1305 is named after Pfc. Adolph Block, who resided on Jefferson Avenue. When he enlisted on June 14, 1917, he was assigned to Company C of the 28th US Infantry. He was the only young man from Mineola to die in action from wounds he received in France in June 1918. It took three years before his remains were shipped home, and in March 1921, he was buried in Greenfield Cemetery with full military honors. The Ladies Auxiliary of the post was organized in 1926. Below, the members are seen in June 1936 as they present a new silk flag to Corpus Christi School in observance of Flag Day. At center, secretary Adeline Gardner is presenting the flag to the Rev. James J. Fitzgerald.

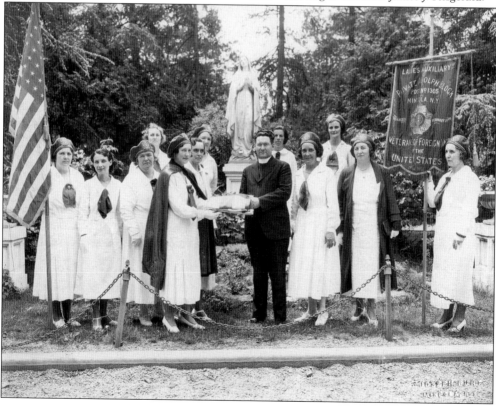

Six

LET US ENTERTAIN YOU

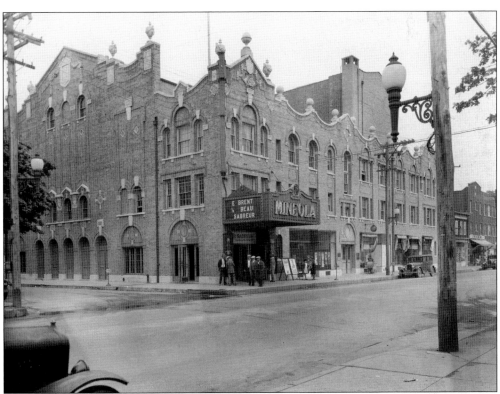

Plans were drawn up in 1925 for an elaborate theater to be erected on Mineola Boulevard and First Street. Two years and a reported $250,000 later, the 1,500-seat Mineola Theatre opened. It featured a marble lobby, velvet seats, a crystal chandelier, and a stage large enough to host Broadway-style productions. The film featured in this 1928 photograph is *Beau Sabreur,* a thrilling adventure of the Foreign Legion starring Gary Cooper and Evelyn Brent. (Courtesy of Queens Library, Archives, Joseph Burt Photographs.)

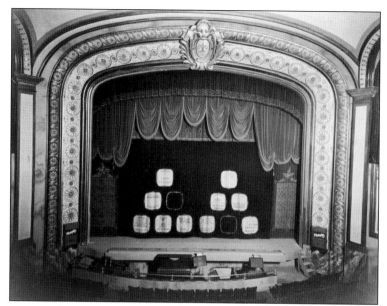

Inside the theater, a nine-piece orchestra would accompany the showing of silent films until 1929, when a sound system was installed for the talkies. Live vaudeville shows were presented on the weekends. Note the local advertisements on the theater curtains. (Courtesy of Queens Library, Archives, Joseph Burt Photographs.)

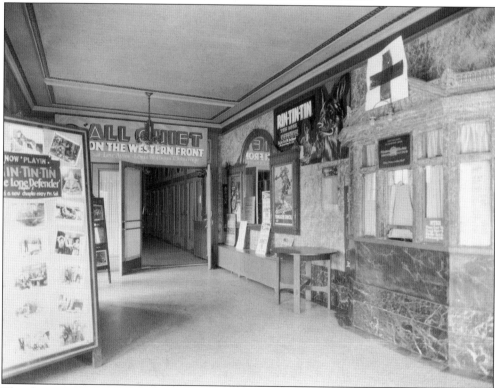

The theater entrance was originally on Mineola Boulevard, under a lighted marquee. A later renovation relocated the entrance onto First Street, lending an even grander atmosphere to the live stage productions presented during that era. In this 1930 photograph by Joseph Burt, the feature film is *All Quiet on the Western Front* and chapter one of a *Rin Tin Tin* weekly serial. A coming attraction features Hoot Gibson in the western drama *Trigger Tricks*. (Courtesy of Queens Library, Archives, Joseph Burt Photographs.)

The Mineola Theatre, reinvented as the Mineola Playhouse under the operation of Frank Calderone, brought famous names and Broadway productions to Mineola in the 1960s. Some of the actors who appeared during that time included Eileen Brennan, Myrna Loy, Liza Minelli, Sammy Davis Jr., and Henry Fonda. Fonda married his fifth wife, Shirlee Adams, at the Mineola courthouse in 1965.

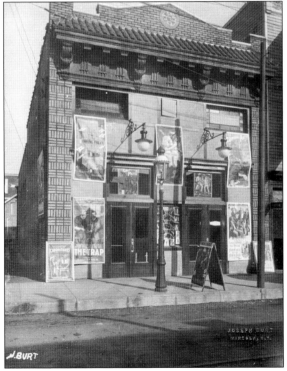

A dedicated movie theater, the Century Opera House opened its doors on the east side of Main Street, south of Second Street, in 1914. The theater showed silent movie "shorts" twice a day in the afternoon and evening. It was said that during the lengthy interval of reel changes, moviegoers would get refreshments at the soda counter in Rushmore's Drug Store next door. In this 1914 photograph, the features of the week included *The Criminal Path, Honor of the Humble*, and part seven of the 15-part serial *Trey o' Hearts*.

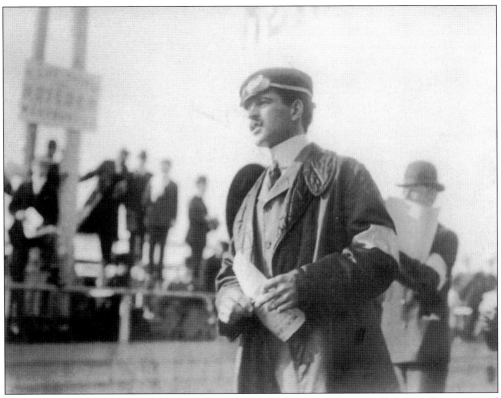

Beginning in 1904, William K. Vanderbilt Jr. established an annual automobile race that attracted drivers from around the world along with thousands of spectators. Mineola was an integral part of these races; its streets were part of the race course, and in 1905, the start/finish lines and grandstands were at Jericho Turnpike near Mineola Boulevard. This 1905 photograph captured Vanderbilt by the Mineola grandstands in his role as referee for the race. (Courtesy of the Suffolk County Vanderbilt Museum.)

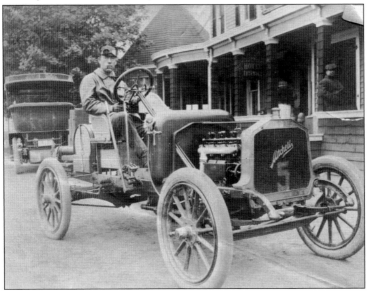

Race car driver H.R. Cousins finished in fourth place in the Nassau Sweepstakes race in 1908. He is seen here outside Krug's Corner Hotel with proprietor "Father" Krug watching from the porch. Cousins averaged a speed of 37.5 miles per hour over the twisting 93-mile course.

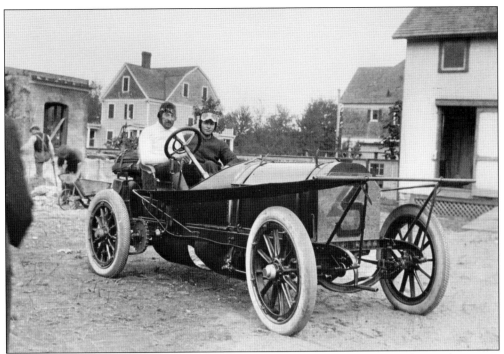

In these 1906 photographs, driver Camille Jenatzy is seated beside his mechanic, a young man named Rodhats. The vehicle, a Mercedes owned by Robert Graves, was entered into that year's Vanderbilt Cup Race. Jenatzy was a well-known racing competitor and the first man to break the 100-kilometer-per-hour speed barrier. He had a fifth-place finish in the race. The event was marred by the unfortunate death of spectator Curt Gruner. That death, coupled with objections to racing along public roads, was the impetus for the eventual building of the Long Island Motor Parkway. Jenatzy and Rodhats are pictured below on Searing Avenue in front of Robert Graves's garage. Cleanup is taking place after the building collapsed during construction, tragically killing three workmen.

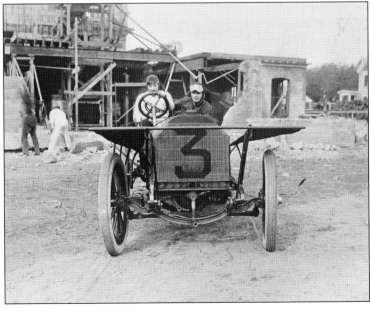

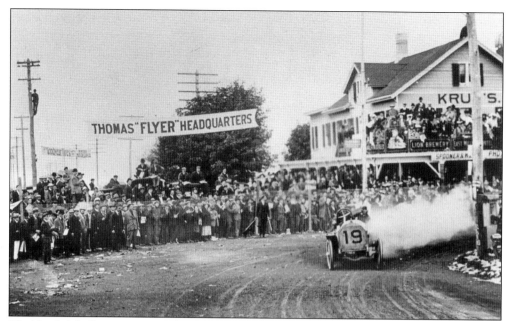

The Vanderbilt Cup race course of 1906 made an exciting turn around the corner of Jericho Turnpike and Willis Avenue. Craning for the best views of Maurice Fabry in car No. 19, spectators lined the roof of Krug's Corner Hotel, climbed utility poles, and dangerously entered the roadway. One spectator was tragically killed in this race just a short distance from this intersection. (Courtesy of the Suffolk County Vanderbilt Museum.)

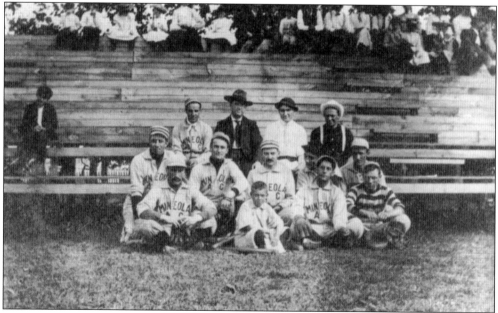

The Mineola Athletic Club formed in 1901. Seen here are the baseball champions of 1907. From left to right are (first row) Dick Allen, left field; and ? Shaw, bat boy; (second row) Ed Buhler, right field; Gus Gleichmann, first base; John Seaman, second base; A. Buhler, third base; Otto Lyon, pitcher; Harry ?, short stop; and Bill Baker, catcher; (third row) Ted Allen, centerfield; Billy McCarthy, manager; George Van Sicklen, scorer; and Billy James, utility man.

GREYHOUND RACES

MINEOLA FAIR GROUNDS

NASSAU KENNEL CLUB

MINEOLA LONG ISLAND

10 RACES NIGHTLY
POST TIME, 8:15 P.M.

GENERAL ADMISSION............25c
(NO MINORS)

- Regular bus service nightly from Brooklyn. Reliable bus terminal, 17 4th Ave. (at 7 P.M.)

- N. Y. C. (buses), 43d St., west of B'way

- Jamaica—Schenck express buses (N. Y. Ave., 163d St., rear of Merrick Theatre). Also 8th Ave. subway at 169th St., and Hillside Ave. (½ hour running time).

- Long Island Railroad to track.

ALL MAIN HIGHWAYS LEAD TO THE FAIR GROUNDS

The Mineola Fair was held once a year, but the fairgrounds hosted events throughout the year. The track and its grandstands saw popular action for greyhound racing. Starting in 1928, the Nassau Kennel Club sponsored 10 races a night, six nights a week. Special trains brought crowds from the city numbering up to 10,000 spectators nightly. One of the most popular and entertaining races on the card was one that used trained monkeys as jockeys.

117

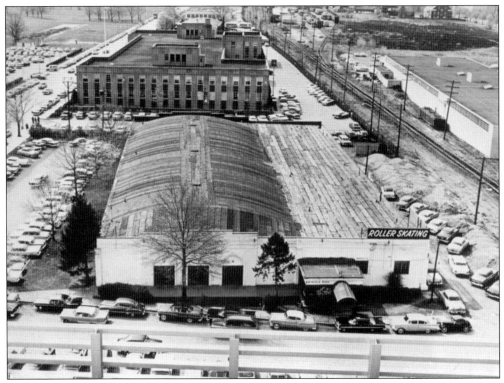

In 1934, a cattle exhibition hall on the Mineola Fairgrounds was transformed into a modern entertainment venue: the Mineola Skating Rink. Professional rollerskating partners Earl and Inez Van Horn spent over $80,000 to create the most up-to-date and innovative rink possible. The large unobstructed interior was improved with the installation of the finest maple flooring, an efficient air-purifying ventilation system, elaborate sound proofing, and a music system featuring the first use of a Hammond electric organ. Suspended overhead was a glittering silver ceiling enhanced by colored lights that lent it a shimmering iridescence, particularly during "moonlight" dance numbers. The rink offered skating lessons, dance instruction, and competitions, and sponsored 60 skating clubs. At the height of its popularity, crowds of up to 3,000 would attend each session.

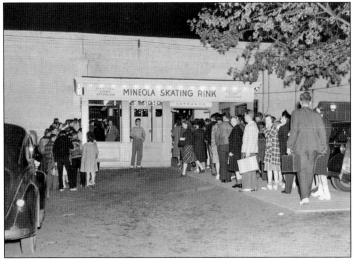

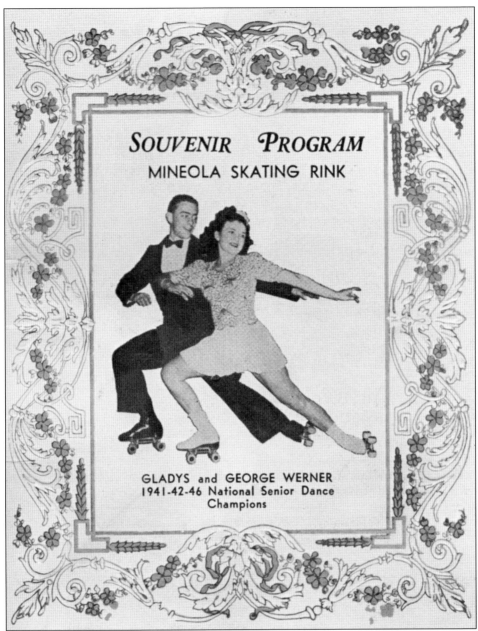

SOUVENIR PROGRAM
MINEOLA SKATING RINK

GLADYS and GEORGE WERNER
1941-42-46 National Senior Dance
Champions

The first official National Dance Skating Championship was held in 1938 at the Mineola Skating Rink. Competitions were held annually for skaters in such categories as junior, novice, and senior men's and lady's singles and pairs. This program, from the rink's 1946 season opening, featured three-time champion dance partners Gladys and George Werner. They performed four exhibition dances including a tango combination, a medley of polkas, and a Viennese waltz medley. The rink frequently held specialty shows showcasing the Werners and many other talented skaters, which proved so popular that the rink had to add bleachers for the crowds. Local Mineola residents Barbara Gallagher and Fred Ludwig were the first postwar World Dance Skating Champions in 1947. The Mineola Skating Rink closed in August 1960 and was demolished to make way for the county office buildings.

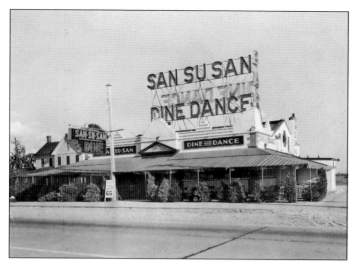

Grant Avenue residents Frank and Mary Caprise epitomized entertainment in Mineola with the opening of both the Sheridan Bowling Academy and the San Su San nightclub on Jericho Turnpike. In the 1960s, the San Su San brought in top name entertainers such as Frank Sinatra Jr., Mickey Rooney, Dick Gregory, and Red Buttons. The nightclub was destroyed by fire in 1978 and was not rebuilt.

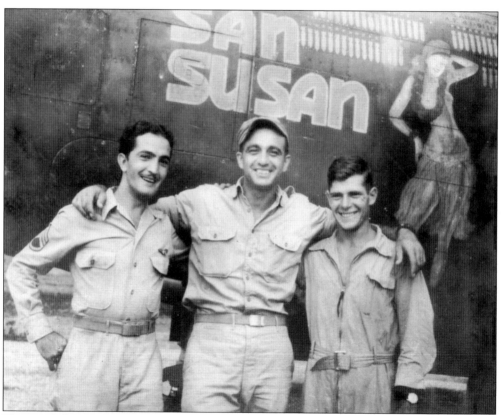

This 1945 photograph attests to the far-reaching influence the nightclub had on its patrons. Lt. Nicholas T. Motto (center) of 115 Jefferson Avenue in Mineola, crew-sergeant Nicholas P. Demetrius of Jamaica (left) and Sgt. Julius Pinner of Sea Cliff (right) pose in front of their bomber, the *San Susan*, while stationed in the Philippines with the 5th Air Force. Motto was a 1933 graduate of Mineola High School and a frequent patron of the nightclub.

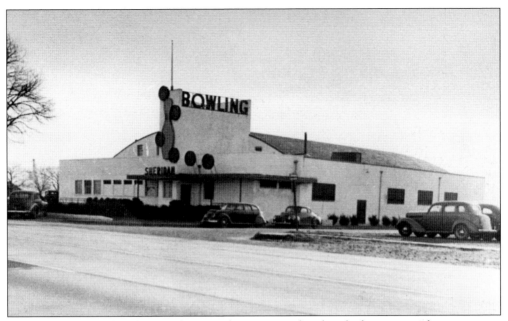

Opening in 1940, Sheridan Bowling Academy was outfitted with the most modern amenities available, including 16 Brunswick alleys, a deluxe bar, and a dining room. Billed as "modern, luxurious, commodious and inviting," the Sheridan Bowl promoted bowing for recreation and exercise. It was, and still is, located on Jericho Turnpike and Sheridan Boulevard.

The Tiny Tim miniature golf course opened on August 30, 1930. It was built by Chaminade Catholic High School during construction of a new school building. Located on the southeast corner of Emory Road, it faced Jericho Turnpike and was open to the public. The proceeds it generated were put toward the cost of the sports stadium to be built on the same property between the school building and the course.

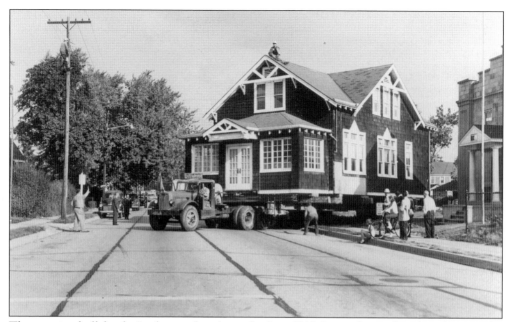

The meeting hall for the Lutheran church was built in 1910. It was donated to the village in the 1940s and moved south down Willis Avenue to its new location on Second Street. The building became known as the PAL House and served as the headquarters for the children's hockey program. It continues to serve today's youth.

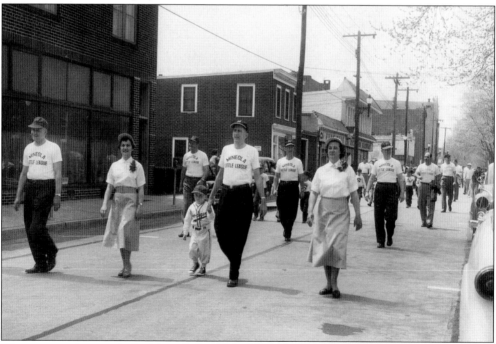

The opening day parade for Mineola Little League was captured by Drennan on May 5, 1955. Then, as now, teams were sponsored by local businesses that advertised on the backs of the team jerseys. Parade routes wound their way on streets south of Jericho Turnpike in the heart of Mineola's downtown area.

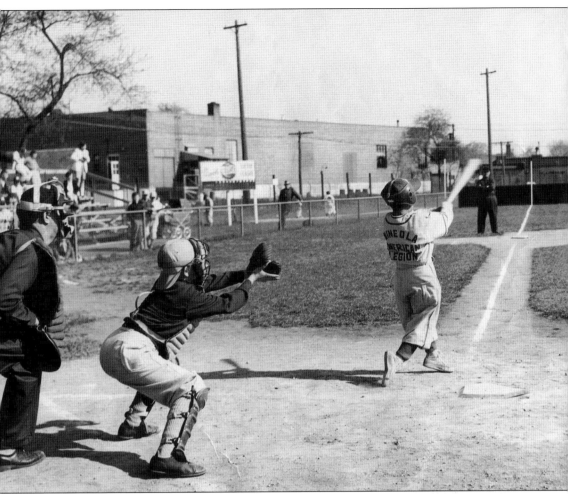

The ballfields where games for Little League are still played today are on the grounds of the former Children's Home. When the property was donated to the village, it was stipulated that it must be used to serve the youth of the community. The current Mineola Athletic Association house was a former outbuilding of the Children's Home. This photograph is dated 1955, possibly taking place after the opening day parade.

Mineola joined villages across the United States to celebrate the nation's bicentennial in 1976. With the help of librarian Lois Bleimann, resident Thomas Barrick compiled photographs and combed through his research to write the first book detailing Mineola's early history. A tremendous birthday cake float was the star of a parade held on July 4, 1976. Village board members dressed as the nation's founding fathers, and Native Americans rode on the float. In the image above, they are pictured on a makeshift stage on Saville Road during the Pledge of Allegiance. From left to right are (first row) trustee Edward J. Mulvihill, Mayor Edward S. Smith (just to the right of the flag), and trustees Isidore G. Irace, Angelo Plaia, and Robert W. Hinck. In the photograph below, this book's author Margaret Ann (left), and her sister Lisa Rae Castrigno pose in front of the cake float. (Below, courtesy of the Castrigno family.)

For its Golden Jubilee in September 1956, Mineola planned many activities, from block parties to athletic and field events to this huge culminating parade. A call was put out for floats to be entered from businesses and social, fraternal, and civic organizations. Businesses outside Mineola were also encouraged to participate. The general parade theme was business and community progress, and it was well attended by residents. Decorative bunting and jubilee banners were hung throughout the town, some of which hang in the historical society today.

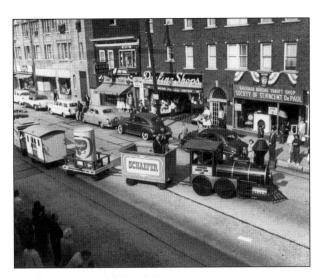

Pride in being a Mineola resident today is just as high as it was for those early inhabitants of the community. To commemorate the 100th anniversary of its founding in 2006, Mineola once again staged numerous events to celebrate. Seen here in period dress just before parade step-off are, from left to right, Michael Marinak, Tom Murtha, and Joyce Gorycki of the Mineola Historical Society. As each year passes into the next, the memories of Mineola become a history worth preserving for future generations. The Mineola Historical Society, with the support of the village and the community at large, will continue to be the caretakers of the shared story.

BIBLIOGRAPHY

Abbott, Patrick. *Airship: The Story of R.34 and the First East-West Crossing of the Atlantic by Air.* New York, NY: Charles Scribner's Sons, 1973.

Barrick, Thomas. *Mineola: Heartbeat of Nassau.* Mineola, NY: Bicentennial committee, 1976.

Carpenter, James W. *The Mineola Fair.* Westbury, NY: Agricultural Society of Queens, Nassau and Suffolk Counties, 1965.

Dade, George C. and Frank Strnad. *Picture History of Aviation on Long Island, 1908–1938.* New York, NY: Dover Publications, 1989.

Kroplick, Howard. *Vanderbilt Cup Races of Long Island.* Charleston, SC: Arcadia Publishing, 2008.

Meyers, Stephen L. *Lost Trolleys of Queens and Long Island.* Charleston, SC: Arcadia Publishing, 2006.

Smith, Mildred H. *Early History of the Long Island Railroad, 1834–1900.* Uniondale, NY: Salisbury Printers, 1958.

Sturm, Robert C. *The Long-Island Rail-Road Company: A History: 1834–1965.* Babylon, NY: Long Island Sunrise Chapter, National Railway Historical Society, 2014.

Tulin, Miriam. *The Calderone Theatres on Long Island.* Hempstead, NY: Long Island Studies Institute, 1991.

Ziel, Ron. *The Long Island Rail Road in Early Photographs.* New York, NY: Dover Publications, 1990.

Ziel, Ron and George H. Foster. *Steel Rails to the Sunrise.* New York, NY: Duell, Sloan and Pearce, 1965.

About the Mineola Historical Society

The Mineola Historical Society is a nonprofit volunteer association dedicated to the preservation of the history of our village.

The society was formally founded in 1988 under the leadership of Mayor Ann Galante. Prior to that time, informal meetings were held in private homes or in the library by citizens concerned with preserving the history of Mineola. The first president, Jack Hehman, contributed many items and photos gathered from his years working for the Long Island Rail Road, which were to form the foundation of the society's collection. Many more photographs, documents, and memorabilia were generously donated and acquired through the years. In 1996, under Mayor John Colbert's administration, the Mineola Historical Society was incorporated into the village, while Hehman was instrumental in securing a permanent building to house the collection on Westbury Avenue.

Today, the society remains true to its purpose of "discovering, collecting, preserving, and publishing" matters of local history. The collection has grown to over 4,000 photographs, yearbooks, historical documents, and memorabilia, including a fine collection of rare red and clear glass objects from the original Mineola Fair.

The society welcomes any and all donations of historical interest relating to Mineola. Public meetings are held on the last Tuesday of each month at 7:30 p.m. at the headquarters at 211 Westbury Avenue, Mineola. We are currently open to the public Monday through Thursday from 9:30 a.m. to noon. Our mailing address is PO Box 423, Mineola, New York 11501. The society may be reached at 516-746-6722. Please feel free to contact us for more information regarding membership, meetings, and donations.

Madeline Maffetore, Recording Secretary
Mineola Historical Society

DISCOVER THOUSANDS OF LOCAL HISTORY BOOKS FEATURING MILLIONS OF VINTAGE IMAGES

Arcadia Publishing, the leading local history publisher in the United States, is committed to making history accessible and meaningful through publishing books that celebrate and preserve the heritage of America's people and places.

Find more books like this at
www.arcadiapublishing.com

Search for your hometown history, your old stomping grounds, and even your favorite sports team.

Consistent with our mission to preserve history on a local level, this book was printed in South Carolina on American-made paper and manufactured entirely in the United States. Products carrying the accredited Forest Stewardship Council (FSC) label are printed on 100 percent FSC-certified paper.

MADE IN THE USA